YOU WILL
BE ABLE TO
**TAKE GREAT
PHOTOS**
BY THE END
OF THIS BOOK

First published in the United Kingdom
in 2023 by Ilex, an imprint of
Octopus Publishing Group
Carmelite House
50 Victoria Embankment
London, EC4Y 0DZ
www.octopusbooks.co.uk

Photographic acknowledgments:
89 John Blakemore
90 The Minor White Archive, Princeton
University Art Museum, bequest of Minor
White (x1980-3391) ©Trustees of Princeton
University. Photo: Allen Chen
93 Rinko Kawauchi. Courtesy
ROSEGALLERY
94 Susan Derges
97 Ralph Gibson
98 Martin Parr/Magnum Photos
101 Paul Hill, www.hillonphotography.co.uk
102 Duane Michals. Courtesy of DC Moore
Gallery, New York

US Edition © Prestel Verlag,
Munich · London · New York 2023
A member of Penguin Random House
Verlagsgruppe GmbH
Neumarkter Strasse 28 · 81673 Munich

A Library of Congress Number is available.
A CIP catalogue record for this book is
available from the British Library.

Editorial direction: Sabine Schmid
Production management: Luisa Klose

Penguin Random House Verlagsgruppe
FSC® N001967

Printed in China

ISBN 978-3-7913-8974-5

www.prestel.com

BENEDICT BRAIN

YOU WILL
BE ABLE TO
TAKE GREAT
PHOTOS
BY THE END
OF THIS BOOK

PRESTEL
Munich • London • New York

CONTENTS

*"Great photographs can
be made in your own
backyard . . . Recognize that
fact and the photographic
world is your oyster."*

FOREWORD

You Will Be Able to Take Great Photos by the End of This Book must be the longest book title ever, but it certainly catches the eye—and this is what Ben Brain is all about. His enthusiasm for the medium bubbles through his easy-to-follow descriptions of the many approaches to photography as he explains how important it is to visually engage with the viewer and make them aware that the most lasting images are usually the ones that are different from those that went before.

In addition to tackling the cornerstones of photography, such as composition, light, timing, and exposure, he dips into historical and contemporary practices to contextualize the medium. Ben also explains that "great photographs" can be made in your own backyard, because it is a fact that most of the time we are where we are instead of where we would like to be. Recognize that fact and the photographic world is your oyster—and speaking of metaphors, Ben also uses his own work to emphasize how photography can transcend the information that is in front of the camera. If readers come to that conclusion, too, it will confirm this book as one that makes a valuable contribution to our understanding of this most glorious medium.

— Professor Paul Hill MBE, FRPS, DFine Art, DArts
www.hillonphotography.co.uk

INTRODUCTION

Welcome to the next step of your photographic journey. Perhaps you're trying to find your photographic voice or realize your creative vision, or you want to comment on the world around you with a camera. Whatever your aspirations, if you want to explore your creativity and discover new ways to engage with the world through the photographic image, you're in the right place.

Photography is everywhere. Literally. Wherever you look, photography will be part of the story. Just take a moment to consider how many photographs in one form or another you've seen today— probably hundreds. It's estimated that nearly one-and-a-half trillion photos were taken in 2020, a number that's this long: 1,500,000,000,000. From fancy-pants DSLRs to smartphones, digital cameras have made photography easier and more accessible than ever before, and a staggering number of people are now taking photographs every second. Essentially anyone with a smartphone in their pocket has access to a sophisticated and high-quality camera. There's nothing wrong with this— in many ways it's wonderful—but it means it is harder to make yourself stand out, especially if you want to use photography as a way of engaging with and commenting on the world around you. The onslaught of photographs cascading through social feeds can feel overwhelming, and if you want your voice to be heard, or should I say

"A good photograph is not usually about complicated techniques or what camera was used, but rather about the attitude, the approach, and the vision of the photographer."

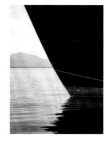

seen, the sheer volume of images can feel daunting. Knowing where to start can be paralyzing if you want to contribute in a meaningful way. A good photograph is not usually about complicated techniques or what camera was used but instead about the attitude, the approach, and the vision of the photographer. This book seeks to explore photography from this perspective, and I hope that by the end of this book, you will have the creative tools and, more important, the attitude to make great photos.

BENEDICT BRAIN @benedict_brain

How to use this book

HOW TO USE THIS BOOK

This book is not a typical how-to-take-photos book.
While some of the core skills are touched upon in the
first couple of chapters, the essence of the book is about
looking, seeing, and finding creative approaches to making
images and using them to engage in the world through
the visual "language" of photography. We will explore how
photography can be used as a tool for self-expression or
as a way to comment on the world in a meaningful way.

The first part of this book will look at some essential
photographic skills, such as composition, understanding
light, timing, exposure, and some basic camera techniques.
We will also touch on some of the philosophical aspects of
photography, art, and making images and consider some
of the core concepts and approaches and how they fit into
the history of photography. Working through this section
will give you the knowledge and key skills to call upon when
needed, and it will inform your creative repertoire.

Once you've got the basics down, I suggest you jump
straight into the projects section and start exploring the
ideas and images for inspiration. The photographs in the
projects have been broken down in such a way that you
will be able to see not only how they were made but also,
more important, why they were made, what makes them
work, what they say, and how they might communicate
ideas or emotions, or comment on the world. Through no-
nonsense, jargon-free annotations, you'll discover ways to
incorporate these techniques into your own photographs.

You will find a wide range of images, from fun and
frivolous experiments for the sheer joy of messing around
within images to more serious, visual responses to
aspects of the world we live in. Wherever you are on your
photographic journey, there will be something for you to
get your creative teeth into. So let's get started . . .

PHOTOGRAPHY TOOLS

The essence of this book is about creativity, storytelling, and finding your photographic voice. It's not an obsessively technical manual bogged down with jargon and explanations on how to use fancy equipment, accessories, and complicated techniques. In the end, the best camera is the one that you have with you and that might well be a simple smartphone camera. There's no need to get hung up on a lot of expensive gear—light, looking, composition, and storytelling are more important. Nevertheless, tools are important, too, so it's good to have a perspective when choosing what to use or buy. So, over the next few pages, we will touch on some of the essentials.

ANATOMY OF A DIGITAL CAMERA

A "proper" camera gives you more control; you will be able to change ISO, aperture, and shutter speed, which we will talk about later. You'll also be able to change lenses.

Committing to a camera system is an important decision, but there are so many choices that it can be overwhelming. Your budget will probably be the most significant factor. You may acquire only one camera and one lens when you start, but you will probably want additional lenses and accessories as you grow creatively.

SLR and mirrorless

Digital single-lens reflex cameras (DSLRs) have typically been the go-to option for serious photographers. However, mirrorless cameras have become increasingly popular in recent years and will most likely continue to outgrow DSLRs in popularity. The main difference is the smaller size and weight of mirrorless cameras.

The advantage of a DSLR is that when you look through the viewfinder, you are looking through the lens and so what you see is what you get. The light is bounced via a mirror and a prism into the viewfinder. When you take a picture, the mirror flips out of the way and the light hits the sensor to make the image. The downside is that the mirror and prism add weight, bulk, and vibration.

In contrast, a mirrorless camera sends image data directly from the sensor to an electronic viewfinder (EVF). These used to be of fairly poor quality and put a lot of photographers off. These days, however, the quality is generally as good as looking through the lens of a DSLR camera, with the advantage being that there's no need for a mirror or a prism, and so these cameras can be made smaller and lighter.

APS-C and full frame

Both DSLRs and mirrorless cameras can come with
different-size image sensors, usually full frame or the
physically smaller APS-C (but occasionally medium
format or Micro Four Thirds). In general, the bigger the
sensor the more expensive the camera. The advantage of
a bigger sensor is the amount of detail it can capture. The
sensor size will also impact other elements, such as the
depth of field and the crop factor of the lenses.

SLR

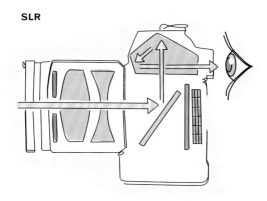

Mirrorless

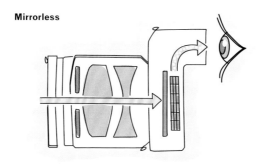

Anatomy of a digital camera

ANATOMY OF A FILM CAMERA

SLR

A film single-lens reflex (SLR) camera is similar to the DSLR discussed on the previous pages, except there's no digital sensor. In place of a sensor is light-sensitive film. Typically, a roll of film will have 24 or 36 exposures. Unlike a digital camera, you cannot change the ISO (a standard measure of light sensitivity), or sensitivity, and you must decide this when you buy your film. Like the DSLR, you look through the lens to make your composition.

Medium format

Medium-format cameras come in all shapes and sizes. They are called medium format because the film they take is bigger than the 35mm film used in SLRs and range finders. The larger film has the advantage of capturing significantly more detail, and it lets you make superlarge prints. Digital cameras also come in medium-format sizes and can have larger sensors. On the downside, medium-format cameras tend to be big and bulky, slow and clunky; hoewver, this can be a good thing by encouraging a more considered and mindful approach.

Anatomy of a film camera

Range finder

Unlike an SLR, on a range-finder camera you look through a separate viewfinder, which, in general, is brighter, and you typically see an area that extends beyond the image frame. Both these factors make them ideal for street and action photography. Like mirrorless cameras, range-finder cameras are usually smaller and lighter. However, because the image is not seen directly through the lens, focusing is a little more challenging. In most cases, if you look through the viewfinder and turn the lens ring, you will see two superimposed images that you need to align. The slight difference between the position of the viewfinder and the main camera lens means there will be a slight discrepancy in the composition, which is called parallax. It's a little like closing one eye at a time and noticing how the view is slightly different, depending on which eye is open.

Large format

Large-format cameras take large sheets of film ranging from 5 x 4 inches to 8 x 10 inches and sometimes even larger. They are superslow and clunky to use. However, the bigger film size will give you an amazing level of detail. Large-format cameras will usually let you tilt and shift the film and lens planes independently of one another. It is technical, complicated, and requires a lot of skill, but once mastered, you will be able to shift planes of focus and avoid converging lines (keystoning) by avoiding the need to tilt your camera up. This is why large-format cameras are popular with architectural and interior photographers.

Anatomy of a film camera

ANATOMY OF A SMARTPHONE

Even if you have an impressive camera with a bunch of lenses, if you don't have it with you, you cannot take a photo. The best camera is the one that you have with you. And these days, more often than not, people nearly always have a smartphone with them. And smartphones have surprisingly good cameras that seem to get better every year.

Small sensor
To keep smartphones small enough to fit in a pocket, their cameras typically have small sensors. This has advantages and disadvantages. The level of detail that can be captured in such a small sensor is much less than a full-frame sensor, so quality is compromised. However, this is only really an issue if you're intending to make superlarge prints, and even then, it's still possible. The small sensor will also create a deeper depth of field and more of the image will appear sharp. This can be good unless you want to get that blurry background effect that's often used in portraits.

Lenses
Until recently, smartphone cameras came with one fixed lens, typically a wide-angle one. Now, in more expensive models, there can be several lenses, from superwide to telephoto and even macro. And if your smartphone camera has only one lens, there are options to pimp it up and buy a clip-on lens. Of course, all smartphone cameras also have a front-facing lens for selfies. This lens is not usually of such good quality, but it's fine for some quick photos not intended to be taken seriously.

The best camera is the one
you have got with you. And
more often than not, it will be
the camera on your phone.

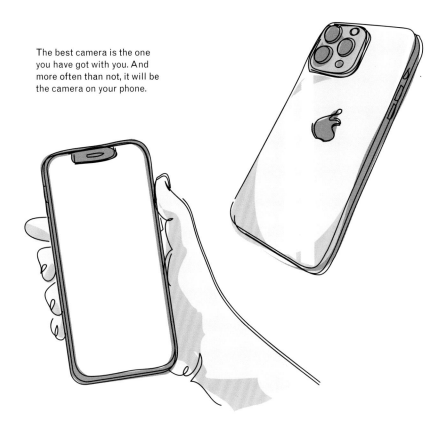

Processing

Not only do you have a camera with you when you're
carrying your smartphone, you will also be in possession
of a sophisticated computer. This means you can edit,
process, and even share your images on the move. All
smartphones will have some native filters and apps for
adding effects to images or just tweaking the tones and
colors. There are also some great third-party apps, which
we will talk about on page 112.

IMAGE-EDITING APPS

Taking a photo with your camera is only the first part of the process. Whether you're using film or digital, you will need to process the film or file to make it shine and realize your vision. The great American photographer Ansel Adams famously compared the photographic negative to a composer's score and the print to its performance. The principle can be crudely applied to digital photography, too, with the raw file being the composer's score and the processed file the "print." Following are a few practical things to consider.

Raw vs. JPEG

Most digital cameras and smartphones will let you shoot raw and/or JPEG files. There are other image file formats, but these are the most common. A JPEG is a compressed file and is small and easy to save and share, especially online. Virtually all the images you see online are JPEGs. If you shoot in JPEG mode, your camera will do a certain amount of processing for you. However, the file will also deteriorate the more you fiddle with it afterward.

In contrast, a raw file is the raw data your camera captures. It cannot be easily shared or viewed, and the data will need to be "processed" and saved as a JPEG (or another file format) before you share it. The advantage is that it is more malleable, allowing for more creativity when processing on a computer. The downside is that raw files often look flat and unimpressive straight out of the camera. They are also big and take up a lot of space on memory cards and hard drives.

Realizing your photographic vision inevitably means some work on a computer. It's less smelly, toxic, and cumbersome than a traditional darkroom but not as magical.

Processing

You will need a computer to process your image files, and anything from a smartphone to a premium MacBook Pro can work. If you are using a smartphone, there will be a bunch of apps you can try, but if you are shooting raw files on a DSLR or mirrorless camera, you will need something with more clout. Like choosing the right camera, choosing the right computer will depend on your ambition and budget. If you're uncertain, it's worth getting expert advice. Processing large image files can be demanding on a budget computer, so you will probably need something that is more powerful.

Storage

Shooting a lot of images will soon start to fill up your computer's hard drive. Ideally, you want to store your data on an external hard drive (another expense). Good practice suggests that you should keep three copies of every file backed up in different places.

There are a bunch of apps you can use to edit your images and we will highlight a few of the more popular ones here.

To subscribe or not

In recent years, a subscription model has started to become mainstream, with software developers, such as Adobe, offering most of their products on a subscription-only basis. It's a model that's polarized opinion, and its pros and cons are dependent on your stance and anticipated usage.

Adobe

It's fair to say that Adobe is the go-to industry standard for many people in the creative industries. The Adobe Photography package has a reasonable monthly subscription fee, which varies depending on where you live, but it is more or less about 10 dollars per month. You will get a whole suite of apps for desktop and mobile devices for your 10 bucks, including the most famous: Photoshop. Lightroom is also included along with many useful cataloging, editing, and workflow tools, not to mention some online storage in the Creative Cloud.

Affinity

Although it's relatively new, Affinity Photo is a fast, efficient, and superimpressive photo-editing package. And what's most attractive, to some, is that it's available on a perpetual license, meaning you will only need to pay once when you initially purchase the software. You may have to buy subsequent upgrades, but the cost is comparatively modest. Regardless, this is probably the best value-for-money image-editing software available.

Capture One

Mostly used by professional photographers, Capture One is designed especially for those working in a studio, where it's perfect for tethered shooting, among other things. Tethered shooting is a way of working with your camera directly connected to a computer. This is useful in a busy studio with art directors, stylists, and clients, etc. all wanting to see what you're up to (and, of course, give you their opinion).

Snapseed

Originally developed by Nik software, Snapseed is now owned and developed by Google. It's an easy-to-use app for Android and iOS that lets you transform your photos quickly and easily by adding stylish effects and filters. It's available for desktop computers and, best of all, it's also free.

LENSES

One of the advantages of DSLRs and mirrorless cameras is the ability to change lenses. It's often argued, and I'm inclined to agree, that if you spend your money on anything, good-quality glass is where it should be spent. Using just one lens with a fixed focal length is an excellent place to start, because it will, without doubt, make you a better photographer. A 50mm lens (or a 35mm lens with a full-frame sensor) is a good place to start and is considered a standard lens. However, there will be a time when you will want to add another lens or two to your creative toolbox. As you grow creatively and start to find a passion for different subjects, one lens might not be enough. For example, if you're interested in the landscape, you may hanker after a wide-angle lens (such as 24mm) to capture a wide vista, or perhaps you might want a short telephoto (such as 85mm) to take flattering portraits, or a long telephoto (600mm) to shoot the moon.

Crop factor

If you're thinking of buying a lens, it's worth being aware of the crop factor. The crop factor relates to the relationship between a lens's focal length and the size of a camera's sensor. For example, a 50mm lens on a camera with a full-frame sensor will feel more like a 75mm on a camera with an APS-C (smaller) sensor. The lens is seeing the same field of view, but the image is being projected onto a smaller sensor and will appear more zoomed in. There's a little more science than summarized here, but this is just to highlight it as something to be aware of.

Prime and zoom

Lenses can be known as prime lenses, which have a fixed focal length, or zoom lenses, which have a variable range of focal lengths. Photographers are often polarized in what they like, and both have pros and cons. Having fewer parts to them, primes are typically (but not always) better quality, especially in low light. They are also lighter and smaller, but you will have to carry more of them to have the same range of focal lengths as a zoom. On the flip side, zooms offer a wider variety of focal lengths in one lens, but they can be heavier and bulkier. Learning to look with one focal length using a prime lens is a great way to get started and hone your eye.

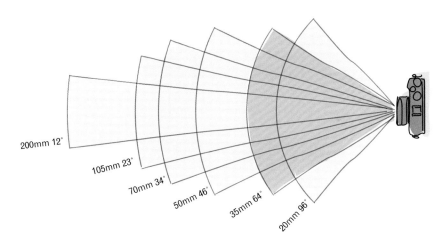

200mm 12°

105mm 23°

70mm 34°

50mm 46°

35mm 64°

20mm 96°

Selecting the right focal length to work with is an important part of the creative process—but having a lot of fancy lenses to choose from won't make you a better photographer.

Lenses

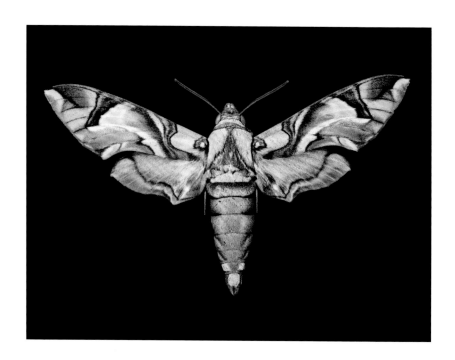

Using a macro lens will
let you get superclose to
your subject, such as this
beautiful moth, and reveal
delightful details or exciting
new worlds.

Photography tools

Fast lenses

If you've ever wondered what photographers are going on about when they talk about a fast lens, they're usually talking about its low-light performance. A lens becomes faster the wider its maximum aperture is. At wide apertures, such as f/2.8 or f/1.4, it's possible to use faster shutter speeds, which can be useful in low-light conditions. Annoyingly, the faster a lens is, the more expensive it typically becomes. For example, a 50mm f/1.4 can be significantly more costly than a 50mm f/3.5.

Bokeh

Another advantage of a fast lens and working with wide apertures is being able to exploit a shallow depth of field. A wide aperture, such as f/1.4, creates an image with a shallower depth of field than a lens with an aperture of f/5.6. A shallow depth of field means more of the image will appear blurred.

The aesthetic quality of this out-of-focus area is sometimes called bokeh (derived from the Japanese word *boke*). The quality of bokeh will vary depending on the lens construction. The bokeh of some lenses is more aesthetically appealing than others, which is why you may hear photographers drooling over a lens's beautiful bokeh.

Macro

There are a bunch of specialty lenses that can be fun and creative to use. Perhaps the most accessible to get started with is a macro lens. Macros will let you focus superclose to a subject and are great for capturing the intricate details of small objects up close, such as the moth on the facing page. The lenses on the latest smartphone cameras often have macro capability, too.

ACCESSORIZE ME

Which accessories you need will largely depend on what you want to photograph. Here are four essentials.

Bag
A decent bag to carry spare lenses, batteries, memory cards, water, snacks, and so on is helpful. Backpacks are good, not least because they evenly distribute the weight. However, it's a pain having to take it off every time you need something from it. Shoulder bags are good for easy access. The trick is to keep your equipment bag as light as possible and avoid the temptation to take everything with you every time you take photos.

Tripod
A tripod is vital if you will be using slow shutter speeds of, typically, anything less than 1/60 second. Sometimes, using flash or increasing ISO resolves the problem. However, some photographers, especially those working in the landscape, don't want to compromise on quality by increasing ISO, or perhaps the subject is too far away for flash, in which case a tripod is a must. It can be a nuisance carrying one around, but it will save you from unwanted camera movement and blurry pictures with slowish shutter speeds.

Shoes
It seems obvious, but whether you're hiking in the mountains or pounding the streets of an urban metropolis, a good pair of shoes is vital. There's nothing like a nasty blister and aching feet to hinder the creative flow. As the great photographer Sebastião Salgado is quoted as saying, "It's more important for a photographer to have very good shoes than to have a very good camera."

Filters

The effects of most filters can be emulated easily in image-editing software. However, there are one or two that you can't fake in Photoshop. A neutral-density filter that restricts the amount of light passing through a camera lens, like a pair of sunglasses, is perhaps the main one. It lets you use a slower shutter speed in bright light, which is perfect for getting that milky-water effect and blurring clouds, if that's your thing. A polarizing filter can also be useful in cutting back reflections and getting deep blue skies. Finally, some folk put a simple ultraviolet (UV) filter on their lenses to protect them from dust and scratches.

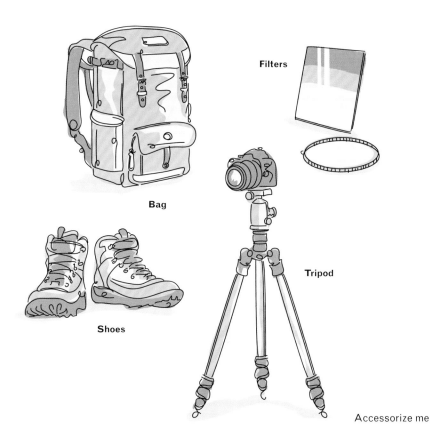

Filters

Bag

Shoes

Tripod

Accessorize me

SKILLS

The emphasis of this book is on creativity and storytelling. It is more about looking, seeing, and engaging with the world through your camera than about fancy techniques and skills. However, understanding and being aware of some basic skills will help you express yourself visually, in much the same way learning to spell words, use grammar, and structure sentences will help you to express yourself with the written word. Over the next few pages, we will look at some of the essential skills, such as understanding composition, light, timing, and so on.

THE ART OF COMPOSITION

Your camera's viewfinder or LCD screen is effectively a frame on the world. You, with your camera, control what to show or not. So, it is vitally important that you're aware of the various ways you can control how what you put in the frame is arranged and how it may be read by a viewer. This is the art of composition.

Composition is essentially the arrangement of the elements in a picture, including the shapes, objects, lines, tones, textures, and colors that form the "ingredients" of your photograph. How you decide to arrange them in your viewfinder or on your screen will affect the way the picture is viewed, but there are a lot of things you can do to alter the arrangement, such as using a different lens, moving an object, or changing your position.

Golden ratio
The golden ratio is based on the number phi (1.618...). To apply it, divide a line into two parts so that the longer part divided by the smaller part is equal to the whole length divided by the longer part.

There are many rules that artists and photographers use to help create harmony, balance, or tension in an image. Most of these principles are rooted in the golden ratio. The golden ratio is based on the Greek number phi (1.618...) and can be translated into visual form by dividing a line into two parts so that the longer part divided by the smaller part is equal to the whole length divided by the longer part. That sounds complicated, but the proportions of the golden ratio can be applied to many aspects of the creative world, from painting and sculpture to music and architecture, and also to the natural world, where the proportions can also be witnessed, which probably goes some way to explaining why we find it so harmonious.

a/b = (a+b)/a = 1.618
You DO NOT need
to use this formula
to get to grips with
composition!

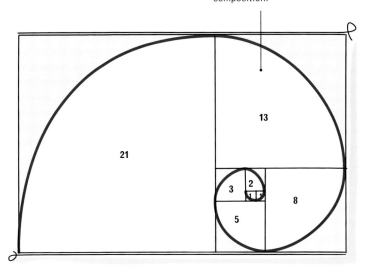

21

13

3

2

5

8

Skills

It's fascinating stuff, but applying it to your everyday photography can be complicated.

Here is an easy guide to help you get started, where I've broken down composition into seven key aspects. Whether you adhere to them or not, it is useful to be aware of them. You will see a lot of images in this book in which the rules have been blatantly ignored. That's cool. These rules are only guides to help you get started if composition isn't something that comes naturally to you. In fact, the more you break the rules, the better. But understanding what is in—or not in—your frame and the relationship of these elements to each other is vital.

For many people, composing is something that comes naturally and it's not a premeditated act, in much the same way that some people can naturally hold a tune, or not. The great twentieth-century American photographer Edward Weston famously said:

"To consult the rules of composition before making a picture is a little like consulting the law of gravitation before going for a walk."

I guess he's right, but he was a genius and clearly had a good eye for a picture and didn't think about it too much.

1 The rule of thirds

It is a lot simpler to put the rule of thirds into practice than the golden ratio and is probably the easiest compositional tool to get to grips with. Imagine there is a grid dividing your image into nine equal blocks. This grid is made up of two vertical lines and two horizontal lines at equal distances from one another. The idea is to position the important elements of your image at one of the points where the lines intersect.

You can also think about positioning the horizon along one of the horizontal lines, so that it's either a third from the bottom or from the top. The rule of thirds can be an effective way to start arranging your photos and to steer the viewer's attention to the important features in an image. It is not, however, a golden standard, and there are plenty of amazing images that violate this rule with abandon. Most modern cameras and smartphones have a grid that can be activated on the LCD screen that can act as a useful visual guide.

2 Leading lines

As the name suggests, this technique is all about using lines to lead the viewer's gaze into the image toward the point of interest and/or the distant horizon. It's easy to use and effective. All kinds of elements in a scene can work, including footpaths, roads, fences, streams, and rivers. Look for ways to include implied lines, such as a person's gaze or the arrangement of flowers in a yard, to strengthen your composition.

1

2

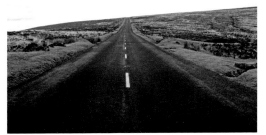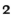

The art of composition

3

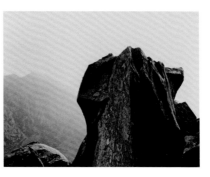

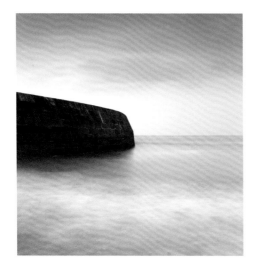

4

5

Skills

3 Foreground interest

It can be a good idea to look for something in the foreground of a scene to act as a visual anchor. Landscape photographers often use this, especially if they're using a wide-angle lens. A good rock in the foreground can be a perfect way to fill the frame and create a sense of depth.

4 Symmetry

The guides we've looked at so far won't work on all subjects and some scenes will require a different approach. In some instances, a precise symmetry might work to accentuate a point. Or perhaps placing the horizon of a landscape in the exact center can be an effective way to communicate a mood, for example, a sense of calm and tranquility.

5 Active space

Although a photo is a static moment frozen in time, it can still imply a sense of energy, motion, and movement. To accentuate this feeling, and to help your action photos make visual sense, think about where a moving object is going and then leave space in the frame for it to move into.

The same principle can be applied to portrait photography, especially when the subject isn't looking directly at the camera. In much the same way you might give a moving object space to move into, it can be a good idea to give a subject's gaze space to look into.

6 Negative space

What you leave out of the frame is as important as what you leave in. Here, the shape created by the space between the buildings is what gives the composition its structure. Take the time to look at the relationship between the elements of your picture and change your position to create a tighter composition.

7 Frame within a frame

This easy technique will be a great addition to your creative repertoire. It's not technically difficult to master and simply requires you to scan your scene for elements that could make a potentially interesting frame. Like many of the other rules we've looked at here, the general idea is to draw the viewer's attention toward the subject and the parts of the image that you really want them to look at. Architectural features, such as windows, doorways, and archways, suit this technique, as do trees, plants, and other foliage. There are potential opportunities everywhere—it's just a question of looking. You'll probably find that once you start noticing useful framing devices, you'll see them all the time!

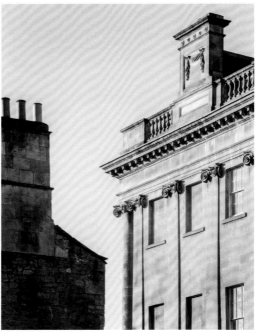

6

7

The art of composition

LIGHT

The word "photography" means "painting with light," and is derived from the Greek words *phos* (light) and *graphê* (drawing). The term is attributed to the English astronomer John Herschel, who coined the phrase in 1839. He was obviously onto something, because we still use it today. So, a photograph is essentially a "light drawing," created when light is captured on a light-sensitive surface, such as film or a digital sensor.

You often hear photographers drooling over the quality of light. Chasing the light and capturing a moment when it conspires in your favor can transform an otherwise dull image into something transcendental.

Understanding light in its various forms and how to control it is a vital part of the photographic process. For example, landscape photographers need a different appreciation of light than studio-based portrait photographers. Light comes in many forms, too: there's natural daylight, ambient light from bulbs, studio lights, LED lights, on-camera flash, and many more. Just look around on an average day and take note of how many light sources there are and how they affect the environment.

Perhaps the best place to get started on your journey of light appreciation is to simply start looking and take the time to notice, in a mindful, contemplative way, how light falls throughout the day in various parts of your domestic space. Look at how the light falls on objects and how it can alter the vibe of the image.

Light

TYPES OF LIGHT

Hard light

A strong, hard light, such as the midday sun on a bright day or the naked bulb of a bright light, can be savage and harsh, with characteristics that include strong shadows and high contrast. It's fair to say that many photographers avoid this kind of light, because it's generally less flattering in landscapes and portraits. However, when used creatively, it can be wonderfully expressive.

Diffused light

The even tones of a diffused or soft light have the opposite effect to the savage rays of hard light and are generally more flattering. There are many ways to soften and diffuse light using a range of modifiers or natural elements. Clouds are probably the ultimate diffuser; a shaded area on a sunny day is good, too, as is the even positioning of studio lights and the use of modifiers, such as softboxes.

Into the light

Shooting into the light—or if you want to sound swanky, "contre-jour"—can yield fabulous results. If you're new to photography, it may feel counterintuitive, but you can achieve wonderful effects, such as rim or backlight around your subject, a lovely sense of depth, and lens flare. Many photographers do their best to get rid of lens flare, but it can be creative in the right hands. Shooting into the sun will fool your camera's light meter, so whether you're using a smartphone or a DSLR, you'll probably have to intervene and override the settings to get what you want.

Types of light

The color of light

It's not just the quality of light that changes through the day—the color of light varies from hour to hour, too. You may have heard photographers talking about the "blue hour," the "golden hour," and so on. They are talking about the quality and, more often than not, the color of light— and they will sometimes get up at ungodly hours to take advantage of it. The Kelvin scale is used to measure the color of light, and the white balance in your camera can control this. In most instances, auto white balance is fine.

The Kelvin scale

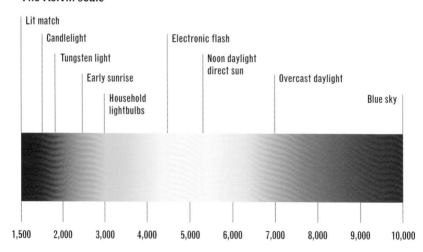

Lit match
Candlelight
Tungsten light
Early sunrise
Household lightbulbs
Electronic flash
Noon daylight direct sun
Overcast daylight
Blue sky

1,500 2,000 3,000 4,000 5,000 6,000 7,000 8,000 9,000 10,000

The color, quality, direction, and intensity of light changes throughout the day, the seasons in different weather conditions, and in geographic locations—it's endlessly fascinating. Get into the habit of noticing it.

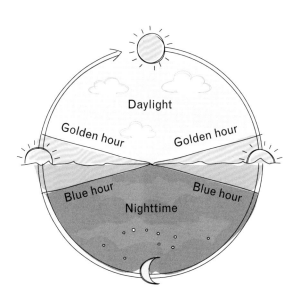

Daylight

Golden hour Golden hour

Blue hour Blue hour

Nighttime

Types of light

Skills

On-camera flash

Many cameras have a built-in pop-up flashgun, and most smartphone cameras feature continuous flash-type light. They can be handy and get you out of a low-light predicament if it's a little dark. However, the light from most built-in flashes can be harsh, unflattering, and challenging to control. By upgrading to an on-camera flashgun, you'll have a little more control and be able to add modifiers to diffuse and sculpt the light. You may even be able to swivel the flashgun's head to bounce the light off a ceiling or wall, which will soften the light.

Studio lights

In a studio-type environment, photographers will often use flash lighting equipment, such as strobes. The great thing about working in a studio is that you have complete control over the quality of the light; you can create hard light and/or soft light, which you can control by using a bunch of modifiers, such as softboxes, umbrellas, and reflectors. However, you need space and the lights themselves can be expensive. You can try renting a studio for a few hours—it's a good way to start experimenting and getting a feel for this environment.

LED lights

LED lights have become increasingly popular. Their main advantage is that they offer a continuous light source, which means you can see what's happening with the light more easily than with a studio flash. This also makes them usable with video and smartphone cameras that don't have any connectivity to studio lights.

THE EXPOSURE TRIANGLE

Making an exposure means letting a certain amount of light into your camera through a lens and onto a light-sensitive surface (film or sensor). The amount of light will determine how dark or light your image appears. Most cameras are clever and can work this out for you, and all you need to worry about is composition, storytelling, or whatever else you want to communicate. However, there may be a time when you want to override your camera and take matters into your own hands.

The sides of the triangle represent shutter speed, aperture, and ISO. Getting these three elements to work in harmony is what makes a good exposure. It's not that simple, however, because each setting will affect how your photo looks. Working out the best exposure depends on your creative vision, but it will inevitably involve a series of compromises.

This is when it's worth having a basic understanding of how exposure works. It's also when you need to start thinking about f-stops, apertures, shutter speeds, and ISOs, which can seem scary.

Most modern-day digital cameras have so many settings, menus within menus, and other fancy features that it can seem a little daunting. However, stripping everything back to basics is the best way to get to grips with exposure—take your time to understand the relationship between aperture, shutter speed, and ISO, and you'll be ready to explore. Forget all the other settings on your camera, and just focus on these three elements. This is why the exposure triangle (see facing page) is often used to teach exposure essentials.

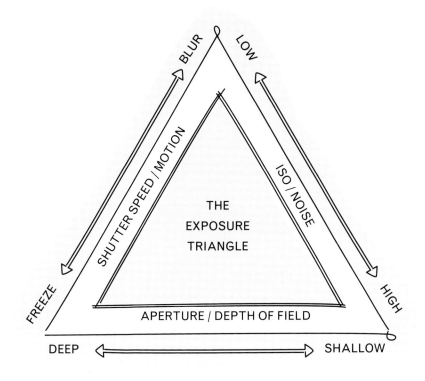

The exposure triangle

Skills

Aperture

The aperture blades in a lens determine the size of the hole that lets light pass through the lens. The size of the hole is measured using f-numbers. A big hole (for example, *f*/2.8) lets in more light, while a small hole (for example, *f*/22) lets in less light. The size of the hole not only affects how much light passes through the lens but also how the image will look. For example, a small hole will create a deep depth of field, where more of the image will appear sharp, while a large hole will do the opposite, with only a small part of an image appearing sharp and the rest looking blurred.

Shutter speed

Think of the shutter as a gate that opens and closes to let light hit the sensor for a determined amount of time, typically fractions of a second. The length of time the shutter is open will have an impact on how your images look, especially if your subject is moving.

ISO

The ISO refers to the sensitivity of the sensor (or film). The higher the number, the more sensitive it is. This is useful in low-light conditions. However, there's a catch, because using a high ISO will also introduce "noise," which looks like grainy dots. So, for maximum image quality, many photographers try to keep the ISO as low as possible.

TIME

When you click to take a photo, your camera's shutter will open to let light pass through your lens onto your light-sensitive surface. Typically, the shutter will be open for a short amount of time, usually less than a second. Once you've found your composition and the light is right, it's down to timing and when you press the shutter. For street, sport, and wildlife photographers, timing plays a more crucial role than in other genres, but regardless of subject, it's useful to get to grips with it and understand how it will affect your images.

The dog catching a stick on an Alaskan beach (facing page) has been frozen in time, thanks to a fast shutter speed of 1/1000 second. Look closely and you will even see water droplets falling from the canine's mouth. The fast shutter speed helps freeze the action, but knowing when to press the shutter was also a crucial part of the process. Find an obliging, stick-loving dog and a friend to throw the stick, and you will have plenty of opportunities to hone your skills. You will no doubt miss the shot many times, but your hit rate will increase with practice.

It's not just a question of when you press the shutter—it's also useful to understand how long the shutter will be open, because this will also affect how your image looks. A shot taken at 1/500 second and one at 1/15 second can produce two completely different images of the same subject.

Try using the shutter-priority setting on your camera. In this mode, you select the shutter speed and the camera will figure out the best aperture. This can be useful if you're in a hurry.

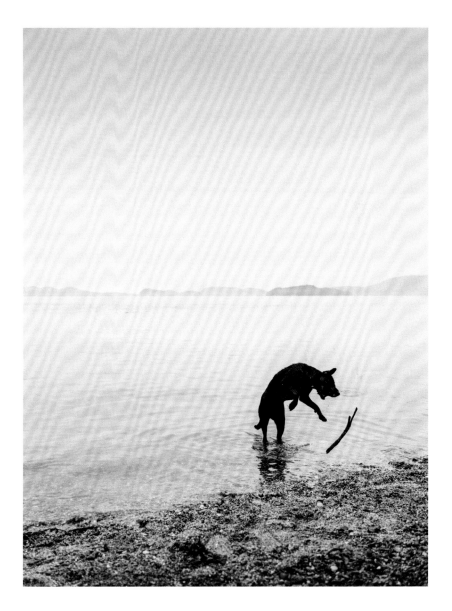

Time

Using a tripod

Despite the seemingly superfast fractions of time involved, there will be a point when your shutter speed will be slow enough to register your body's movement, which will make your image look blurry. How slow depends largely on how steady you are, how heavy your equipment is, and whether your camera and lens feature image stabilization. Regardless of these factors, there will be a point when you need to use a tripod. As a rough ballpark time, anything slower than 1/60 second is worth getting your tripod out, if you have one. If not, you will need to think about your exposure and adjust your ISO and/or aperture accordingly.

ICM

Intentional camera movement (ICM) is another technique to put into your creative toolbox. It's a way to create an impressionistic feeling that some feel resonates on a visceral level. It can be a lot of fun to experiment with, but use it cautiously and only when it suits your artistic intent. The idea is to deliberately move your camera during a slowish exposure. How much you move it and for how long depends on what you are photographing and how you want the photo to look. The best solution is to experiment and find out what works for you. It's fun!

Still water

These two images are of the same scene and were taken within minutes of each other. One was taken at 1/500 second and there is detail on the water's surface.

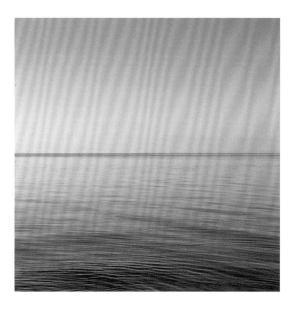

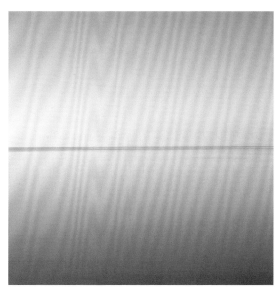

The other was a 30-second exposure and the passage of time has been recorded in the long exposure, with the moving water appearing smooth and blurred. The camera was kept steady on a tripod, so the horizon remained sharp. To keep the same exposure value, the aperture was smaller (*f*/22), so less light hit the sensor but for a longer period of time. There is no right or wrong here, just a different way of using the shutter speed to evoke a different vibe.

GETTING CREATIVE

Once you've got to grips with the basic controls of your camera and you have an appreciation for composition, light, and timing, it's time to hone your skills and start getting creative. Sometimes this can be a surprisingly daunting prospect. What to photograph, why to photograph, and how to go about it can become poignant and sometimes paralyzing questions. This section features some fun exercises to help stimulate creativity, some cool creative projects to try, and a basic introduction to ideas around landscape, portraiture, and documentary photography to whet your creative appetite.

FINDING YOUR CREATIVE MOJO

No matter where you are in your photographic journey, there is always room to improve, develop, and grow. Experiencing new ideas, techniques, and approaches to photography can invigorate your work. Sometimes, the experiences can be fruitful, sending you down paths that change the direction of your photography forever, and other times they don't. The fact is, if you don't try, you will never know. It's good to break out of your comfort zone and try something new. Whether you jump wholeheartedly into the deep end or you tentatively dip your toes in at the water's edge, it doesn't matter. What does matter is trying.

Sometimes, it can be difficult knowing where to start and how to get the creative juices flowing. Conceiving and, most important, beginning a project can be the first hurdles. The Norwegians use the phrase "the doorstep mile," which alludes to the first steps of any journey being the hardest. The same is true of a creative photography project—taking the first shots can be the hardest part.

". . . exercise your eyes, mind, and camera skills to grow as a creative photographer."

Words such as "deadlines," "accountability," and "boundaries" might not be the first things that come to mind when you contemplate creativity. They are, however, more valuable than you might think and can help stimulate the creative process. The following pages feature a bunch of quick and easy exercises for you to try. They may be the start of your life's great work or yield results that never see the light of day. It doesn't matter. Just as you need to go to the gym and exercise regularly to grow strong, you need to exercise your eyes, mind, and camera skills to grow as a creative photographer. So, let's get started . . .

Getting creative

Finding your creative mojo

365 project

Taking photographs every day for a year is a great way
to flex your creative muscles and be actively engaged
on a daily basis. Post them on a social feed, such as
Instagram, and factor in some accountability, too. The
trick is to pick a subject or theme that you know you will
be able to realistically photograph every day. This example
was simply a case of photographing the sky from a
similar point of view. If nothing else, it was an interesting
meteorological study.

A walk in the park

This challenge is guaranteed to make you a better
photographer, especially if you do it regularly. If you've
ever set aside some time to make photographs and walked
out of your front door, camera in hand, and suddenly felt at
a loss on what to shoot, this is the perfect antidote.

The premise is simple: Choose a route and set a timer
or stopwatch for a predetermined time. Depending on the
length of your walk, 5 minutes is a good starting point.
When the alarm goes off, stop, take a moment to look
around you, look up, look down, and consider how to
respond photographically to your surroundings. You will
be surprised at how creative you have to be when forced
to react to a specific place.

These images were taken on a 6-mile hike in rural
Somerset, UK, stopping every 3 minutes and taking
20 images an hour, regardless of location. The walk took
about 4 hours, so there were 80 images to choose from.
A harsh edit down to 20 images or so and you have
potentially got a coherent, consistent body of work.

365 project

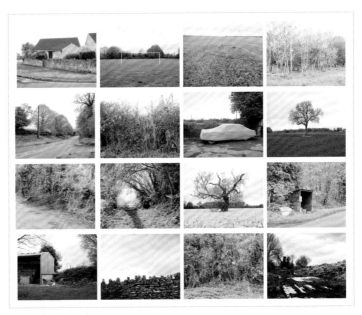

A walk in the park

One lens . . . **. . . one year**

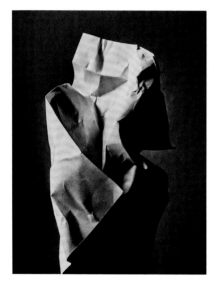

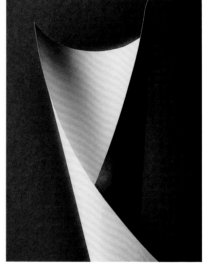

Paper diaries

Getting creative

One lens, one year

If you have a bunch of lenses to choose from, or even a zoom lens with a range of focal lengths, the paradox of choice can start to hinder rather than help the creative process. So, remove the dilemma of which lens to use and commit to using just one focal length for a year. Perhaps start with 35mm or 50mm—these are close to the approximate field of view the human eye sees, so they will feel relatively natural. You will learn to really see, and if you need to be closer or farther away, use your feet.

The paper diaries

Keep a sheet of plain white paper near a window. Every day, set aside 5 minutes to take a photograph of it. There is no need to use a top-of-the-line camera—a smartphone camera is fine. Be creative and reflect your mood in the way you twist, curl, curve, or crumple the paper—you may need a fresh sheet every day! Explore the shapes, curves, creases, and the way the light behaves—maybe the light is hard and full of contrast or soft and gentle—and how these can be used to interpret your mood.

This should be a quick and easy exercise. Try not to overthink it; be spontaneous and go with your gut instinct. Use only natural light from a window and try to exclude any background distraction, so your attention is focused on the paper. Try to get into the habit of doing this exercise every day and keep the images as a visual diary of your mood. Perhaps even make it into a 365 project (see page 64).

Melody maker

Select a piece of music or, ideally, get someone else to choose some music for you. The idea of this fun and creative project is to listen to music and think about how it makes you feel. Try to avoid music with lyrics—the words can be distracting and may tempt you to illustrate them instead of interpret the vibe of the music. Using the creative toolbox of skills, techniques, ideas, and approaches that you can find in this book, set about producing one or maybe even a series of images that reflect your interpretation of the sounds.

This image was taken while aimlessly meandering the suburban streets of a Costa Rican port town while listening to "Miles Runs the Voodoo Down" from the classic Miles Davis album *Bitches Brew*. Getting into the heady jazz groove, the seemingly chaotic vibes started to take on a sense of harmony. Suddenly, this scene presented itself and the chaotic, intense pinks and yellows, along with the organic foliage shapes, which contrasted with the fence and barbed wire, spoke eloquently to how the music made me feel at the time.

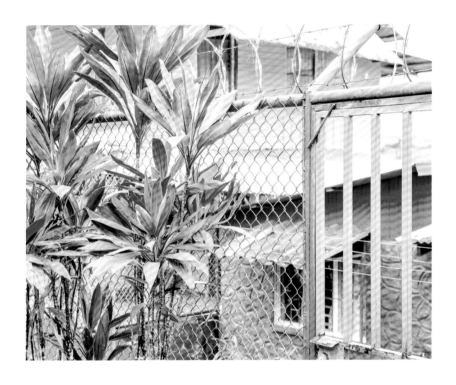

Finding your creative mojo

NOW TRY THESE FUN IDEAS

Pinhole

Believe it or not, a lens was not used in the making of this image—it was made with nothing more than a simple wooden box! The box was sealed tight of light except for a tiny pinhole on the front. In complete darkness, a sheet of light-sensitive film was positioned in the box opposite the hole before it was closed and sealed. The exposure was made by positioning the camera and removing tape from over the pinhole for about 5 minutes.

There are many ways to enjoy this process. To get started, all you need is some photo-sensitive paper and a light-tight container, such as a metal can or small cardboard box. The pinhole can be made with a fine needle. You will need a few photo chemicals—developer and fixer—to process the paper once you have made an exposure, which you will need to do in the dark. It's fairly easy and relatively inexpensive to create a makeshift darkroom in a closet or bathroom. If you want to skip this part, it can also be done in a photo lab.

Exposure times can be several minutes long, depending on the brightness and the size of the pinhole—this process is all about experimentation! Not only is it fun and creative, but it will also help you understand the basic principles of photography. However, composing can mean some trial and error, because there's no viewfinder to help you frame the scene. This image was made using a sheet of 5 x 4-inch color film and processed in a photo lab.

There are plenty of pinhole-photography resources available online. You can get ideas from UK-based pinhole aficionado Justin Quinnell (www.pinholephotography. org), who is fun, informative, and ace! And look online for workshops and supplies in your local area.

Now try these fun ideas

Getting creative

Cyanotype photogram

Making a cyanotype (blueprint) print is another way to get creative with the fundamentals of photography. Start off by simply making contact prints of objects, such as ferns, plants, and lace. Prints made directly like this are known as photograms. Some early twientieth-century artists, such as Man Ray and László Moholy-Nagy, made beautiful photograms. Anna Atkins's botanical studies, made almost a century earlier, are even more impressive.

To make a cyanotype photogram, simply place an object on light-sensitive paper and expose it to ultraviolet light (that is, sunlight). The process doesn't require any special equipment—all you need is ultraviolet light and cyanotype-treated paper. Coating the paper is relatively straightforward. In a darkened room (it is fine to leave on a regular lightbulb), simply brush or sponge the cyanotype emulsion onto a fine-quality artist's paper (relatively heavy and acid-free paper works best). Once dried (use a hair dryer for speed), arrange the objects on the paper and place in direct sunlight.

It is possible to purchase precoated paper or premixed chemicals, both of which are easily available by searching online. They remove some of the mess and hassle from the process, but you will also lose a little of the magic. For the ultimate in kudos, acquire the raw chemicals—ferric ammonium citrate and potassium ferricyanide—and mix your own. However, be extremely careful and follow the safety precautions!

Multiple exposure

Most digital cameras, and even smartphone apps, will let you make multiple exposures. Multiple exposure is simply the layering of one image on top of another. In analog days, this was achieved by recocking the camera's shutter after taking a photo but, crucially, not advancing the film, so a second exposure was made on top of the first one, effectively sandwiching the two images together. The results could be interesting, if unpredictable. Digital cameras allow for this feature in differing ways, so check your camera's manual. Several smartphone apps for iOS and Android have this feature, too, or are designed specifically for the purpose.

The top image was made of eight exposures to try to capture the essence of the wind. It was inspired by the photographer John Blakemore (see page 88), who created a wonderful body of work along the theme. The camera was on a tripod, so the tree trunks didn't move during the exposure. The leaves rustling in the wind did move and were in a different position for each of the eight shots. The images were then layered on top of one another.

For the bottom image, I placed stones I'd collected from a beach in Conwall, in the southwest of the UK, on a light box, changing the angle each time, and layered the shots in camera.

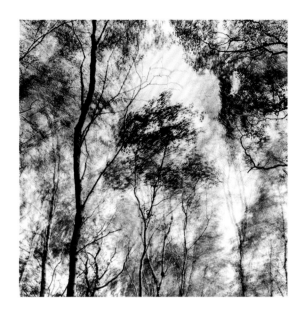

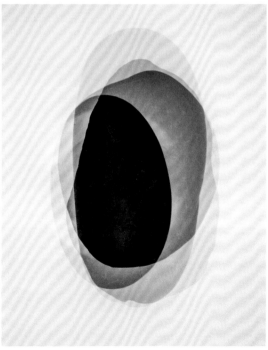

Now try these fun ideas

3-D fun

Getting involved in three-dimensional (3-D), stereoscopic imaging is not nearly as complicated as you might think. The anaglyph process is possibly the most enjoyable and rewarding place to begin. Naturally, you will need to shoot two images to replicate the stereoscopic vision we have from our left and right eyes. Try to simply move a handheld camera a little to the right between shots. The two images will need to be merged in image-editing software, such as Photoshop, or if you prefer, there are a number of apps for iOS and Android that will make life much easier.

You will need a pair of red/cyan 3D viewing glasses. A small package of cardboard ones is relatively inexpensive and easily available online. It is a truly magical process and a lot of fun to experiment with.

Go abstract

Creating an image that is nonrepresentative of a specific place, object, or person is a great way to flex your creative muscles and hone your eye. Colors, tones, shapes, and textures can all be used effectively, and while not specifically representative, they may serve well to evoke a mood or emotion. This can be an exciting way of thinking about photography.

These images show the side of a boat, but they are not about the boat—they are all about the color and shape. Start off by getting close and isolating parts of a scene, so it's not immediately obvious what the subject is. There are potential abstract images everywhere.

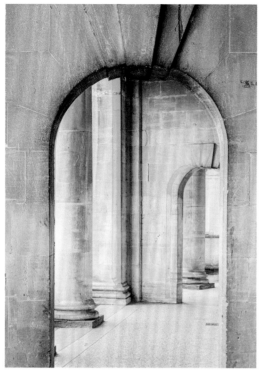

3-D fun

Go abstract

Now try these fun ideas

LAND

In what is an abbreviated microhistory of landscape photography, this section outlines three different approaches to photographing the land.

Pictorialism, the *f*/64 group, and the New Topographics

Not long after the invention of photography, photographers found themselves playing second fiddle to the art world. They felt the establishment didn't take them seriously enough. For some, this is an issue that still rumbles on nearly two hundred years after the invention of photography.

As a result, pictorialism emerged and photographers, such as Frederick H. Evans, Henry Peach Robinson, and Alfred Stieglitz, emulated painterly approaches to raise photography's status. Photographers would use montage techniques to create a complex tableau (they would have loved Photoshop), or soft-focus lenses to create ethereal, romantic, and painterly effects.

By the 1930s, attitudes were shifting. Modernist ideas started to inform the artistic direction for some. In California, photographers, such as Ansel Adams, Imogen Cunningham, and Edward Weston, formed Group *f*/64. The guiding principles of the group were the antithesis of those of the pictorialists. Members were concerned with creating and showing unapologetically photographic work—pure photography with no attempt to emulate the art world. Their images might seem conventional to us now, but in 1932, when they had their first exhibition, they would have been radical.

Taking another generational leap to the 1970s, a group of photographers calling themselves the New Topographics emerged. Photographers, such as Robert Adams and Lewis Baltz, evolved a deadpan aesthetic

and focused their lenses on the more banal aspects of landscape, looking at humanity's relationship with the environment by photographing everyday subjects, such as suburban development in the United States.

So, which type of landscape photography do you identify with the most? There is no right or wrong answer, but thinking about your approach and using this information as a springboard for further investigation is a great way to start your creative journey.

PEOPLE

It is impossible in the few pages here to summarize the vast spectrum that falls broadly under the umbrella of photographing people, so here are some ideas to whet the appetite and explore further.

The portrait, the diarist, and the self

Photographers have always made images of fellow humans, from corporate headshots and fashion shoots to social documentaries, the selfie, and everything in between. A good portrait—an image that transcends a mere depiction of a subject's features—is a nuanced art, and aside from technical skill, it requires the photographer to connect with the subject to reveal something of his or her personality. The skill is as much about making human connections as it is about photography. Look at the work of Richard Avedon, Harry Borden, and Jane Bown for inspiration.

Some photographers, such as Arnold Newman, made "environmental portraits" in which the subject was depicted in a setting that added to his or her story and persona. Perhaps his most famous image is of Igor Stravinsky at a piano. Newman's approach was particularly formal and structured.

By adopting a more informal snapshot aesthetic, photographers in the 1970s, such as Nan Goldin, pioneered a candid style of photographing friends, life, and everyday experiences through a diary-esque approach. Goldin's seminal body of work, *Ballad of Sexual Dependency*, was revolutionary at the time and is worth researching further, as is Richard Billingham's *Ray's a Laugh*.

The self-portrait has been prevalent in photography from the beginning. Despite the technical challenges of photographing yourself, it can be an interesting subject to explore and better still, you don't need to find a subject. Look at the work of leading photographers, such as Francesca Woodman, Cindy Sherman, Jo Spence, Lee Friedlander, and Man Ray for inspiration.

Since the introduction of smartphones and their front-facing cameras, the selfie has become a dominating presence on social media, with subjects (myself included) projecting their often-idealized lifestyles to the world.

DOCUMENT

From reportage and photojournalism to art documentary
and social realism, the camera has become a vital tool
in recording and documenting the human condition,
news, and world events.

Recording the world

Reporting world news and traveling with an incredible
amount of equipment would have been difficult for early
photographers, such as Roger Fenton (1819–69). His
Valley of the Shadow of Death (1855), taken during the
Crimean War, is cited as one of the earliest photographic
records of war.

Half a century or so later, rapidly evolving technology
heralded the advent of smaller, handheld cameras, freeing
photographers from the tyranny of the tripod and large,
unwieldy cameras. Henri Cartier-Bresson is among the
photographers who embraced the technology and freedom
it facilitated. The Frenchman danced the streets, capturing
fleeting moments of life and reporting on world stories.

In 1947, Cartier-Bresson—along with fellow photographers Robert Capa, David "Chim" Seymour, George Rodger, William and Rita Vandivert, and Maria Eisner—formed Magnum Photos. It was created as a cooperative and, crucially, the members retained the copyright to their work. Today, Magnum is arguably the world's most prestigious photograph agency. However, the work produced by the agency's photographers is different to the early days and reflects the changing styles and approaches to photojournalism and documentary photography through the decades. This shift is perhaps best illustrated by the acceptance of UK-based photographer Martin Parr into the organization in the 1990s (see pages 98–99).

As a record of reality, there are many issues to consider around the idea of "photographic truth," even though photographers have been manipulating images since the beginning of photography. For example, Camille Silvy (1834–1910) was "faking" scenes in the mid-nineteenth century, a long time before Photoshop. In the context of documentary and photojournalism, manipulating the truth has serious ethical implications and is highly taboo. Today, "fake news" is a hot subject. Even Roger Fenton's photo, mentioned previously, is considered to be faked, as evidenced by two versions of the same image with cannonballs in different locations. This is food for thought.

What are your thoughts on the world around you? Is there something you would like to comment on? Or perhaps you want to raise more questions and stimulate debate? Photography can be a powerful tool to help you do this.

LEARNING FROM OTHERS

The history of photography (and art) is rich with visionary practitioners who have helped shape the course and development of the medium in its relatively short history. Gaining an understanding of the history of photography and seeking out photographers that resonate with your creative ambitions is a vital part of growing as a photographer. You will soon start to notice lineage as you begin to see who has been influenced by whom, and how the medium has evolved and developed. It's fascinating. The following pages highlight some of the key photographers who have in some way influenced and inspired me. But this is just the tip of the iceberg.

PHOTOGRAPHERS

Creating a comprehensive survey of important photographers to study, analyze, and learn from is a monumental task. There are weighty tomes that only touch the surface, so to attempt to do so in the few pages here would be foolish. Despite being a relatively new art form, photography has evolved swiftly, both conceptually and technically, to being arguably the defining art form of the last two hundred years.

Despite the enormity of the task of covering the history of photography, it's useful to have some perspective and points of departure for further inquiry. So, I thought hard about some of the photographers who have in one shape or form influenced the rest of the images that you see in this book. Some of them were my direct tutors, while others have been a source of inspiration and guiding beacon in my practice. They were all chosen for bringing something to me that was inspiring, whether it was John Blakemore's use of metaphors, the poetic gaze of Rinko Kawauchi, Ralph Gibson's design sensibilities, or Duane Michals's sense of narrative.

". . . explore the work of great photographers and get a sense of the history of photography and who the movers and shakers were."

One of the most useful things you can do to develop your vision as a creative photographer is to explore the work of great photographers and get a sense of the history of photography and who the movers and shakers were. Start collecting photography books, study the works, learn from them, be inspired by them, and build aspects of them that resonate with you into your own practice. In time, your own photographic voice might emerge.

Learning from others

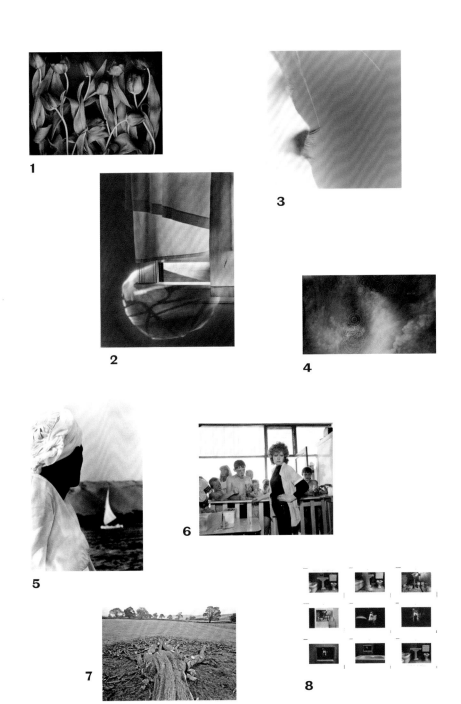

1

3

2

4

5

6

7

8

Photographers

JOHN BLAKEMORE

(b. 1936)

John Blakemore is one of Great Britain's most revered photographers. His work defies classification and to a large extent he could be described as "genre fluid." He taught himself photography after seeing Edward Steichen's 1955 *The Family of Man* exhibition in *Picture Post* magazine. In 1992, he won the Fox Talbot Award for Photography, and he was made an Honorary Fellow of the Royal Photographic Society in 1998. He became well known for his work in landscape, but the scope of his oeuvre reaches much further, in particular, to extensive periods of visual inquiry into still life, tulips, and bookmaking.

Blakemore is a master craftsperson and his understanding and control of the silver print, his chosen means of expression, is second to none. Blakemore uses the principles of the Zone System, a method developed by American photographer Ansel Adams for calculating exposure and development time to completely control of an image's tonal range. The results are sublime, and to appreciate them, you have to see his prints in real life—nothing else does them justice.

However, it is not just Blakemore's mastery of the silver print that is inspiring. He is also a deeply cerebral, spiritual photographer. He was a pioneer in photography education and I had the good fortune to be one of his students at the Derby School of Art. Blakemore inspired me profoundly. As a young student, he opened my eyes and mind to the idea that a photograph could hold metaphoric meaning (among many other things).

Tulips, from the
Celebrations series, 1994

John Blakemore

*Windowsill Daydreaming
(72 N. Union Street, Rochester)*,
July 17, 1958. Gelatin silver
print. Image: 11⅝ x 9¼ inches
(29.5 x 23.4 cm); sheet:
14 x 11 inches (35.4 x 27.8 cm)

Learning from others

MINOR WHITE

(1908–76)

Photographer, writer, editor, educator, and critic are just some aspects of creative polymath Minor White's résumé. He pioneered new ways of looking, thinking, and feeling about photography and hung out with some of the great American photographers of the early twentieth-century towering figures, such as Alfred Stieglitz, Ansel Adams, and Edward Weston (all worthy of further research beyond these pages).

White is quoted as saying that he learned technique from Adams, a love of nature from Weston, and from Stieglitz, "the affirmation that I was alive and could photograph." Stieglitz created a series of photographs of clouds, which he called Equivalents. The images may not seem so radical now, but at the time, these images were revolutionary explorations into making abstract images and would have made an impression on White, who also experimented with abstraction and was more concerned with how the viewer feels than representing an object or thing. His primary motivation was a quest for spiritual transcendence using photography.

White was also part of a group of photographers that, in 1952, founded the photography magazine *Aperture*. White was appointed the magazine's first editor, a position he held until his untimely death in 1976. *Aperture* is still in publication today and is arguably one of the world's finest magazines for serious photographers. It is expensive but worth it.

Interestingly, the work and teachings of Minor White had some influence on John Blakemore (see page 88)—it's all connected!

RINKO KAWAUCHI

(b. 1972)

When people talk about the work of Japanese photographer Rinko Kawauchi, you'll often hear such words as lyrical or poetic being used, and for good reason. Kawauchi's images have a beautiful, radiant vibe that speaks to the idea of visual poetry. She explores and describes the world through photography with the awe and wonder of a child's inquiring, curious gaze.

She told legendary British documentary photographer Martin Parr, who is largely responsible for introducing Kawauchi's work to the West in 2004, that we all have these childlike feelings, but they have become latent. Her aim is fueled by a desire to tap into these feelings and show them to the world through her photography. Her inquisitive eye explores quiet, small, and easily overlooked corners of everyday life with a reverence that transcends the seeming banality of the subject.

Kawauchi predominantly works in color, with a subtle, gentle palette and delicate tonality. Her work has also been cited as being influenced by Shinto ideology, which recognizes (among other things) that all things on earth have a spirit.

Kawauchi is also a prolific publisher of photography books. This image is from one of her first books, *the eyes, the ears*, published in 2005, which was also the first book of hers that I bought.

Untitled, from The Eyes, the
Ears series, 2005

Rinko Kawauchi

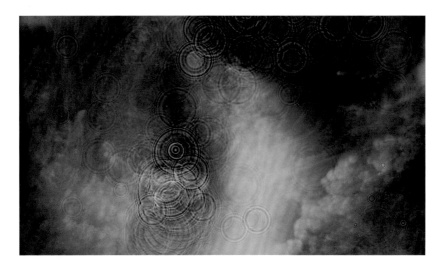

Eden No. 2, 2004. Lambda print,
44¾ x 75 inches (114 x 190.5 cm)

Learning from others

SUSAN DERGES

(b. 1955)

I can still remember the first time I came across a Susan Derges print in the flesh—it was an awe-inspiring, revelatory moment. It was a massive photogram of the Taw, a river in Devon, England. A photogram is essentially a camera-less image, typically made by placing an object on a sheet of light-sensitive paper and exposing it to light. In this case, Derges had submerged (in the complete darkness of night) a large sheet of light-sensitive paper into the river and made a fast exposure using flash lighting, which artfully captured all the shapes and patterns made by the moving water.

Like each of the photographers showcased here, Derges's work transcends the technical aspects and, in this instance, is more concerned with how the water can be a metaphor for other aspects of our world beyond what is visible; she is exploring ideas about what underlies the visible.

I later saw more of Derges's work in one of the best photography exhibitions I've ever seen: *Shadow Catchers: Camera-less Photography* at the Victoria and Albert Museum, London. Her images were shown alongside other practitioners in camera-less photography, such as Pierre Cordier, Adam Fuss, Garry Fabian Miller, and Floris Neusüss, all of whom are inspiring and worthy of further inquiry.

RALPH GIBSON

(b. 1939)

US-based photographer Ralph Gibson first came onto my radar when I was a student. I was immediately seduced by the sense of design, structure, and composition in his predominantly black-and-white images. However, it wasn't just the design sensibilities—I enjoyed his visceral, clever, and playful way of seeing the world.

Gibson started as a photographer in the US Navy and went on to assist Dorothea Lang and Robert Frank, both of whom I urge you to research if you have not already come across their work. In an interview, Gibson described learning the need for a point of departure with making his images from Lang, meaning he won't pick up his beloved Leica without a reason for making a photograph and placing it into the context of a bigger whole. From Frank, Gibson learned the need to strive for originality.

Throughout Gibson's prolific career, he has been a champion of the photography book and even started his own publishing house, mainly out of a desire for complete editorial autonomy. While Gibson's compositions are sublime, with every part of the image carefully considered, his work is also more nuanced, with recurring themes, signs, and symbols creating his own unique semiology. Of this image, he said:

"Prior to visiting Egypt for the first time in 1989, I happened to read *Triste Tropics* by Claude Levi-Strauss. He explained how various cultures use signs and visual systems. Once there, not speaking Arabic, I noticed immediately that the point of the felucca sail was similar to the point of the date palms as well as the tip of the obelisks, etc. I followed this shape as an act of discovery. The Ethiopian boatman fell into deep shadow as I composed with my Leica and 50mm lens."

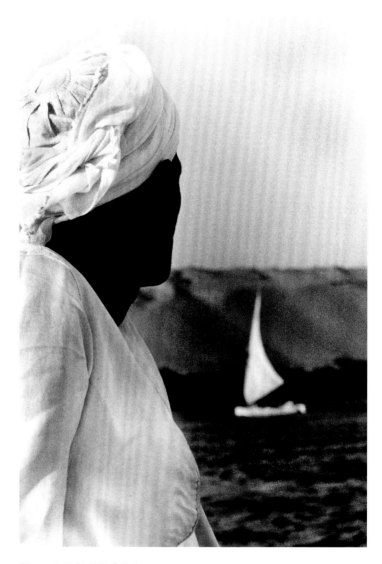

Pharaonic Light, 1991. Gelatin
silver print, 14 x 11 inches
(35.5 x 27.9 cm)

Ralph Gibson

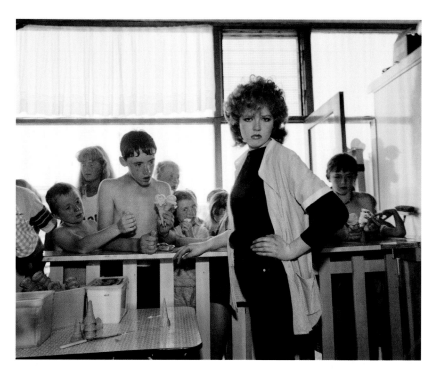

New Brighton, from
The Last Resort series,
1983–85

Learning from others

MARTIN PARR

(b. 1952)

British documentary photographer Martin Parr, along with other photographers, such as Paul Reas, Tom Wood, and Paul Graham (among others), pioneered the use of color in British documentary photography. Parr's use of on-camera flash and color film produced stark, harsh, and insanely intense images that soon became his trademark aesthetic. Traditionally, documentary photography had been exclusively made in black and white, so when Parr and others started using color, it rocked the boat. Parr became a member of the prestigious photo agency, Magnum, in 1994. However, his admission into the exclusive photo club raised some eyebrows, especially with the old brigade, who were uncomfortable with his style and approach. Strangely, his work still seems to polarize opinions, especially among enthusiast photographers who tend to either love or hate his work.

This image was taken from *The Last Resort*, a body of work that was pivotal for Parr and arguably British documentary photography. Between 1983 and 1985, Parr visited the Liverpool beach resort of New Brighton and made the work. His unflinching portrayal had plenty of critics but can arguably be seen as a seminal body of work in the history of British photography.

Parr is also a champion of the photography book and has a huge collection; he has written (with Gerry Badger) several volumes of books about photography books and has published more than 100 books of his own work. In 2017, the Martin Parr Foundation opened in Bristol, England, to support photographers making work focused on Great Britain and Ireland and to house a growing collection of photographic works, including his own archive. It is right next to the Royal Photographic Society, making it a great photo destination.

Martin Parr

PAUL HILL
(b. 1941)

Paul Hill began his career as a photojournalist in the 1960s. However, he soon migrated from the world of commercial and journalistic work to a more art-based practice. Like Blakemore (see page 88), Hill was a pioneer in photographic education and, along with his work with art schools and universities, he also set up the Photographers' Place in the heart of Derbyshire, UK, as a center for workshops and study. Here, he showcased a steady stream of some of the world's leading practitioners.

The *Felled Tree* is part of Hill's landscape work, but unlike the mode du jour of using cumbersome tripods and large-format cameras, Hill would use a 35mm camera, leaving him free to roam unconstricted. There was a certain punk aesthetic, attitude, and whiff of antiestablishment to his approach. His work was more about ideas—comments on us and our relationship to the land—than capturing pretty chocolate-box pictures.

"A photograph that attempts to show simply how wonderful nature is poses very few intellectual challenges," Hill explained to me recently. He went on to tell me that he felt many camera users appeared to rely on the possession of expensive and sophisticated equipment for their reputation instead of demonstrating their ability to make difficult, intellectual judgments when taking pictures. It is this mindset that Hill and others have instilled in me, and that has inspired and informed much of my own making of images.

*Felled Tree, Eldon Moor,
Derybyshire*, 1983. Gelatin
silver print, 12 x 15¾ inches
(30.5 cm x 40.2 cm)

Paul Hill

Things are Queer, 1973.
Nine gelatin silver prints
with hand-applied
text; each image:
$3^3/8$ x 5 inches
(8.6 x 12.7cm); each
paper: 5 x 7 inches
(12.7 x 17.8cm)

Learning from others

DUANE MICHALS

(b. 1932)

Working with sequences, multiple exposures, and text are all synonymous traits of the incredible work of the great photographer Duane Michals. It is virtually impossible to talk about narrative and storytelling in photography without somehow linking the lineage back to Michals.

He started as a graphic designer in New York, but after a three-week visit to Russia in 1958, with a borrowed camera, his journey into artistic photography began. In the subsequent decades of his practice, he has weaved a playful path that has pushed, pulled, and challenged photographic conventions.

The work pictured here, titled *Things are Queer* (1973), is perhaps one of his best-known pieces and exemplifies his work from this period. Using a series of nine photos, Michals explores an intriguing, playful narrative with a surreal, dreamlike twist. We start and finish with the same image, but our perception of reality is different by the end of the sequence.

This, and much of Michals's other work, raises questions about our ideas of the world we live in. He cites the surrealist painter René Magritte and the author Lewis Carroll among his influences, and traces of this influence are clearly apparent in his work.

As an aside, he speaks eloquently, unpretentiously, and with mischievous humor about photography and his practice. Search online for interviews and podcast features—you won't be disappointed.

Duane Michals

FINISHING TOUCHES

When the Kodak Brownie was introduced more than a hundred years ago, the advertising slogan read: "You press the button—we do the rest." George Eastman, the founder of Kodak, coined the phrase in 1892. However, making a great photo is about more than clicking the camera's shutter. Even with the ease of making photos in the twenty-first century with everyday tools, such as smartphones, there are still decisions to make after pressing the shutter and before showing your image to the world.

Over the following pages, we will look at basic image-editing workflows and ways to "process" your files, from selecting your images and changing the mood to exploring ways you can share your work. There are myriad ways a file can be rendered, tweaked, toned, pushed, and pulled, and each way will affect the way your image is perceived and read by a viewer.

EDITING AND SEQUENCING

One of the big differentiators between serious photographers and enthusiasts is what they choose to show and not show. It's all in the edit, and editing images is an art in itself—many magazines and newspapers will specifically employ picture editors to do just that. It is a great skill to be able to look at a raw body of work and recognize the images that tell a story or communicate an idea. We will explore some of these ideas over the next few pages. First, let's deal with some of the nitty-gritty.

Backup

After transferring your images from your camera and before you do anything else, make sure you have your files backed up. The 3:2:1 backup strategy is a good place to start. It stipulates that you should have at least three copies of your files, on two different devices, at least one of which is stored in a different location to your home. However, it's easier said than done, especially if you shoot a lot. There are loads of good cloud-based storage sites, too. Whatever you choose, make sure you do it—there's nothing worse than a hard drive failure without a backup.

File naming

Some photographers use software to name and catalog their images, while others prefer to sort and store them manually. It doesn't matter how you do it, so long as you can find the images again. It is staggering how quickly an archive can grow if you're being productive, and you need to be able to locate your images with ease.

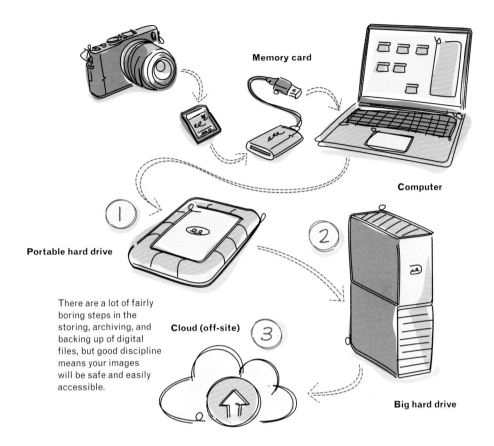

Memory card

Computer

Portable hard drive

1

2

There are a lot of fairly boring steps in the storing, archiving, and backing up of digital files, but good discipline means your images will be safe and easily accessible.

Cloud (off-site)

3

Big hard drive

Star rating

There are many apps to help you edit your images, including perhaps the most popular: Adobe Lightroom. Among other things, it has a great cataloging feature. Whatever you use, after transferring your images from your camera to your computer, you will need to decide which images you want to work on. Using a star-rating system is best. Make a couple of passes, applying a different star each time. Initially, disregard any misfires or images that are out of focus and so on. Whittle down your selection until you have a concise and consistent set.

Storytelling

Once you have rated your images and decided on a set, you're ready to start sequencing your work into a story or coherent body of work. Sequencing fine-art images for exhibition in a gallery is completely different from editing for a six-page magazine feature or your Instagram feed. So, the first thing you need to consider is the audience and where you intend to showcase the images.

A classic magazine editorial might follow a more traditional narrative, in that you might start with an establishing shot that sets the scene, followed by midrange shots and details. Perhaps there are characters in your story who will need to be introduced, too. Are the protagonists doing things, or are they headshots or environmental portraits? These are all things to consider.

If you're working on an exhibition that's less about a conventional story, start to play with the images and see how they look on a wall. Laying out small (4 x 6-inch) prints and moving them around, experimenting with pairings and juxtapositions, is a great way to get started. It's amazing how changing the order can alter how the overall set of images can be read by the viewer.

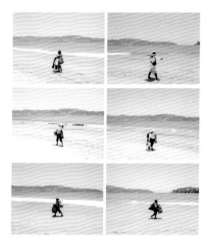

Diptychs and triptychs

As an exercise, try positioning two (a diptych) or three (a triptych) images together and see how one image feeds off another and how they can project a new meaning collectively. It's a fun, useful, and interesting concept to play with.

Consistency

To help unify a small body of work, it is vitally important to think about how you process your images. Whether you are using an Instagram filter or more heavy-duty image-editing software, such as Photoshop, you should consider how your images will look as a whole. The photos should be consistent with one another. If the vibe of your story or project feels like it needs a soft color palette, with low contrast and airy tones, don't include gritty, grainy, high-contrast black-and-white images in the set—unless you are doing so to deliberately create tension.

IMAGE PROCESSING

Realize your vision

Whole books are dedicated to the art of processing and editing images. So, in the few pages here, we will just have to whet your appetite for further inquiry. The most important thing to communicate is that there are often many ways to interpret a file. Despite what many people may tell you, the right way is whatever method helps you to realize your creative vision.

Take a look at the three images on the right—they are all versions of the same raw file, but using the sliders in Adobe Camera Raw, three completely different images have been made. None of them is more right or wrong than the others, just a part of the creative decision-making process. They exude a different vibe, and that is what is so interesting and fun about the creative process.

Why raw?

In many cases, it can be useful to set your camera to capture raw files. A raw file straight out of the camera typically looks less impressive than a JPEG; however, it gives you more information to play with on the computer, because it hasn't been processed or compressed by your camera. So, while a raw file might not initially look as attractive as a JPEG, you will have a more malleable file to work with, one that you can push, pull, and squeeze more than you can a JPEG using image-editing software, such as Adobe Lightroom or Camera Raw.

The raw file, straight off the camera

Image processing

ON THE PHONE

The totally awesome thing about a smartphone is that
you have absolutely everything you need to shoot, edit,
and share your images in your pocket. This is mind-
boggling, especially when you consider that the first
iPhone was released less than 20 years ago (June 2007).
The computing power, not to mention the quality of the
cameras, is simply staggering. The native cameras and
image-editing software on most phones are perfectly
adequate in most cases, but there are a few apps that can
be useful to add to your creative repertoire.

Snapseed

This is a great little app. There are a bunch of cool effects
that are easy to use, from adding light leaks and grungy
textures to skin smoothing and color and tone enhancing.
It's tempting to crank the sliders to the full, but try to
exercise restraint—excessive use of filters doesn't look
good. There are other cool features in Snapseed, too, such
as being able to make double exposures, add creative
frames, and even text. Best of all, it's free and available for
Android, iOS, and desktops.

Adobe Lightroom (mobile edition)

This is a slightly different version from the main desktop
version, but many of the features will be familiar if you are
already using Lightroom. It's a powerful tool if you want
a little more control of your processing than most native
image-editing apps offer. You will be able to shoot and
edit raw (DNG) files through the app and use a bunch of
sophisticated tools, such as curves, gradient masks, and
geometry corrections. It's free, but a modest upgrade will
unlock additional features. If you are already embedded
within the Adobe suite of photo apps, it makes sense.

Slow Shutter

This is a creative app that let you effectively shoot with long shutter speeds, perfect for capturing light trails or achieving that silky, milky effect with moving water.

Snapseed

Adobe Lightroom

Slow shutter

SHARING YOUR WORK

Once you have shot, edited, and processed your work, it's ready to share and send out into the world. After all, it would be a shame to keep your images locked away on a hard drive for nobody to see. There are many ways to share your work, in both the real and digital worlds, and we will explore some of these in the next couple of pages. Whatever your ambition, it can be a healthy and fulfilling way to be part of a wider creative community. With so many images being made and uploaded every day, there are sure to be a bunch of creatives that share some of your sensitivities and ways of seeing the world. Find your tribe and start conversations—these dialogues, whether on social media, at a camera club, or part of a creative collective, can be hugely rewarding.

Social media
Instagram is currently the go-to image-sharing platform. To date, more than 40 billion images have been shared, there are more than a billion active users, and 95 million photos and videos are uploaded to the platform every day. Wow! Making yourself stand out from the crowd can be a daunting prospect, and chasing likes, kudos, and followers probably won't make you a happy, creative photographer. However, it can be a useful vehicle to build a community of like-minded creatives. It can also be a great space to discover new and exciting work and to even build meaningful connections.

Website
A more solid and controllable way to have an online presence is to build a portfolio site. There are loads of beautifully designed off-the-shelf sites that for a small fee will host your site, and some of the ready-made templates

are surprisingly slick. More often than not, you don't need to know anything about web design at all—you can easily get a basic but professional-looking site up and running in less than a day. Typically, packages will include a portfolio of your images, an online store to sell your prints, a blog to share your news and views, and a newsletter sign up. Newsletters are a great way to build a community and speak directly to your audience. Best of all, you won't be dependent on social media algorithms.

MAKE A ZINE

A "zine" is a small, cheaply produced magazine, the kind popularized by rock and pop bands in the 1970s and 80s. The word is derived from "fanzine," a combination of "fan" and "magazine." Often made using nothing more sophisticated than a photocopier and staples, zines have seen something of a revival in recent years, especially among photographers. With digital technology and easy-to-use online printing services, it is possible to quickly and inexpensively make a rough-and-ready zine, with little knowledge of publishing required.

Making a short run of 8½ x 5½-inch zines shouldn't set you back much, and it is a great way to share and distribute your work. You may even make a few bucks selling them online, but it should be embraced more as a way to get your work seen than making a profit. The real art of making a compelling zine is in choosing the right subject and thinking about the pace, flow, and rhythm of your image sequencing.

Make a book

If the rough-and-ready vibe of a zine isn't your thing, think about making a beautifully handcrafted book. It's not as complicated as it sounds and there are a bunch of videos that will help you through the steps. Better still, many photographers and bookmakers offer workshops. Either way, there's nothing more satisfying than leafing through a handmade, limited-edition book of your work.

Print and exhibit

In my humble opinion, a good old print is still the best way to realize your creative vision and share your work, regardless of whether an image is destined for a gallery wall or not. I like to make 4 x 6-inch prints of my projects as a nondigital way to play and experiment with image sequencing and storytelling. It can be useful regardless of whether you are planning an exhibition or sequencing for a book or zine.

Holding an exhibition can be expensive, and there are a lot of elements to consider, from gallery rental to printing and framing. Taking part in a group show or placing a few images on a local coffee shop wall is a good place to start.

NFT

How about creating a nonfungible token (NFT)? This is a digital asset with a unique ID tag that is stored on the "blockchain" (a cryptocurrency thing), so that it can be traded using cryptocurrency, typically Ethereum. NFTs are all the rage at the moment, and everyone seems to be talking about them. A few photographers appear to have made huge amounts of money, while others (me included) haven't made a penny. Not everyone is convinced by NFTs, and there are also some ethical questions hanging over the environmental impact of mining cryptocurrency, which is concerning.

PROJECTS

The projects in this section have been selected to offer a wide range of approaches to photographic practice. They are offered as creative springboards from which they will hopefully stimulate ideas, spark a creative urge, and help you on your photographic journey. Each project has been broken down, and I explain my rationale for making the image, how I went about it, and why I made the decisions I made. There is a lot to dig into, and the more you explore, the more you will discover about yourself and your photographic voice.

LEARN TO LOOK
BEAUTY AND THE BANAL

There are great opportunities to make photographs just about anywhere. Some photographers are all too often seduced by the sensationalism of a particularly attractive location, aspiring to be there at the magic hour to get the idyllic shot. On a superficial level, that can be satisfying. However, by recalibrating your eye and your visual perception of a place, it is possible to enjoy making photographs just about anywhere and at any time. The lack of an obvious shot will make you a better photographer in the long term. The creative boundaries imposed by

"The creative boundary imposed by banal locations can be a good thing."

banal locations can be a good thing—they will make you work harder and ultimately see better.

This image of a shabby, dilapidated sink on the side of the street somewhere in Malaysia is about as far removed from an attractive location as you can get, but as a photograph, it works. First, it's a question of noticing the potential and stopping to appreciate it, to consider and be mindful of the form, the flow, the structure, the lines, the colors, and the shapes and how they work together. The yellow walls, the black mold, and the rickety structure of the pipes and sink come together in a harmonious and balanced composition. It reminds me of a lurching flamingo hanging on for life. Perhaps it could be seen as a metaphor, although for what I'm not sure.

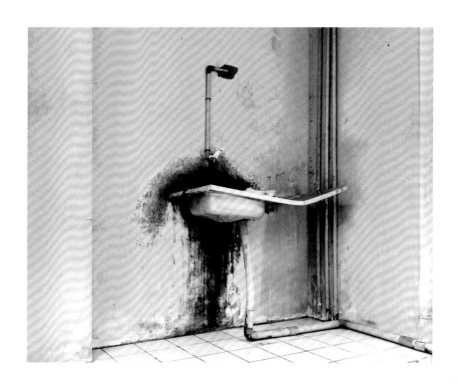

Learn to look

1 Learning to look and notice things is an art in itself—it's easy to focus on the big shot and inadvertently ignore the moments of harmonious beauty in seemingly banal little corners of the world and daily life.

2 Being mindful of the composition helps create respect for the scene—paying careful attention to keeping the verticals straight in this image helps elevate the status of the subject, making it more worthy of the viewer's attention.

3 The tones and colors have been handled in such a way as to give the overall vibe of the image a delicate atmosphere, with subtle layers of depth. Notice the little piece of green string—this creates a wonderful little accent to the otherwise predominantly yellow image.

4 On the surface, this could be just a picture of a dilapidated old sink on the side of the street. However, it could also be a visual metaphor and take on an alternative meaning. Does it look like a lurching flamingo to you? It does to some. What could this mean?

THE LANGUAGE OF PHOTOGRAPHY
CONCRETE SKIES

A solid mass of concrete dominates this composition's top half, creating a dramatic, dystopian sky. In contrast, rising out of the darkness at the bottom of the frame, we see foliage gently fluttering in the breeze. The juxtaposition creates a visual tension. The slightly ethereal effect of the vegetation has been captured with a slowish shutter speed of about a second. The moving foliage reinforces the relationship between concrete and plant and the way in which the image can be read.

It can be interesting to explore how we use the language of photography to help tell a story. For example, the slow shutter speed gave the foliage an ethereal vibe, accentuated by its lighter tonality, which could be a way to communicate a sense of fragility. There is also a lightness that emanates from the background, which could be seen as a way to communicate a sense of optimism and a glimmer of hope, while the heavy, oppressiveness of the concrete sky could speak to the threat of humanity on the natural world.

The creative use of tonality, composition, and exposure all send signals, telling the viewer how to interpret the image.

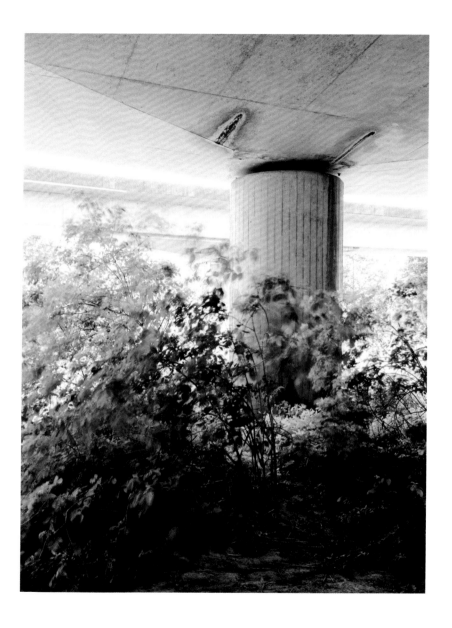

The language of photography

1 While the image works well in color, in this case, converting it to black and white helps draw attention to the textures, shapes, and tonality.

2 The movement of the foliage has been blurred using a long exposure, which reinforces the delicate nature of the vegetation against the harsh concrete structure. If you are using a smartphone, try using Live View (iPhone) mode or similar to get the same effect.

3 The relatively tight composition without any visible sky enhances the oppressive nature of the concrete overpass, which in turn becomes a replacement sky. This reinforces the sense of conflict that can be seen in humanity's relationship with nature.

4 Another seemingly banal location reveals that it is possible to make engaging images just about anywhere. It doesn't get much less exotic than under a highway overpass.

1

Projects

NATURAL LIGHT

Creating a home studio for making a still life doesn't need to be complicated or expensive. This setup is about as basic as possible, using a regular kitchen table and natural light from a window. The more consistent and diffused light from a north-facing (northern hemisphere) window is preferable. Velvet is a beautiful background fabric, because of how it absorbs the light; however, sheets of colored paper can do just as well. The primary light source is from the window on the right of this subject, but a modest reflector was fashioned out of aluminum foil to reflect some light into the shadow area on the left side.

The way you choose to light an object will also affect how you see and read it. Even a mundane object, such as this anatomical model of a human heart, can present new meanings and narratives, giving it a new lease of life. With natural lighting and a makeshift studio, a certain surreal quality has been coaxed out of the scene. As seen through the gaze of a camera, the heart's valves, veins, aorta, and arteries appear almost monstrous. Perhaps it even feels anthropomorphic in its haunting, almost menacing presence. The positioning of the heart, the angle of view, and the amount of negative space also speak to how the image might be perceived.

1 Natural light is the cheapest light source around. However, it's not just a fiscal rationale that makes it so attractive—it is also lovely to work with. Light from a kitchen window and a small reflector fashioned from aluminum foil were all that was needed to make an image with depth and vibrance.

2 Selecting an appropriate background is as important a choice as the object. In this case, black velvet was used, because it absorbs the light wonderfully and is a because fabric to work with. However, simple sheets of colored paper can also work.

3 After contemplating the shape and structure of this model heart in a mindful and considered way, it started to take interesting new features and become more than just an object. The next step was choosing the right light, space, background, and setting to communicate this feeling.

4 In this example, the subject's valves, veins, aorta, and arteries took on a monstrous, anthropomorphic form. Naturally, this can be read in many ways and have a metaphoric meaning, which is an exciting way to work with still life.

POINT OF VIEW
A SENSE OF PLACE

In the tradition of classic travel photography, you could argue that this romantic scene (bottom image, facing page) speaks to the mystery of exotic, far-flung corners of the world. Maybe it even echoes, in part, the great travelogs of early twentieth-century photographers, such as Burton Holmes (1870–1958). But does it reflect a sense of place? Not really. Take a look at the image above, which was taken at more or less the same time. Notice how both photos feature the same three palm trees. Two different images can be realized by simply changing position, angle of view, focal length, and/or frame of mind. One is not better or worse than the other—they are just different. Perhaps this exercise speaks to the growing awareness around photographic truth.

The bottom image is arguably more satisfying aesthetically—it is reasonable to suggest that it might sit more comfortably on a living room wall as a decorative piece. In contrast, the other image may be more humdrum in its vibe, but it possibly reveals a more accurate, albeit less exotic, depiction of the location.

So, what you choose to keep in your frame or leave out, how you position yourself, and even how you process and present the image are vital aspects to consider in your practice. Try approaching a scene in two completely different ways to communicate different stories.

Point of view

1 Changing lens, viewpoint, angle of view, and attitude helped reimagine this scene. Compared with the other photo (see previous page) of the location, this alternative version of the scene creates a more aesthetically pleasing, albeit superficially decorative image.

2 Stripping back the composition and leaving out distracting elements helps simplify the image, isolating the trees in their own space and making it more graphic and focused on shape, tone, and structure. Odd numbers generally make more satisfying compositions, too, so the fact that there are three trees is helpful.

3 Converting the image to black and white and adding a slight yellow/sepia tint alludes to the aesthetics of vintage travel imagery. Processing is just another device in the creative repertoire to help reinforce the story's intent and manipulate the way the image is read.

4 The boat between the trees was a stroke of luck, because it came along at just the right moment. Waiting until it was in position was simply a matter of timing. It adds a subtle human element and sense of narrative to the overall composition.

Projects

NARRATIVE
MYSTERY

A stranger with two dogs stands near the edge of a cliff looking out to sea. One dog's presence is only implied through a telling leash, while the other dog looks away from its human companion. The protagonist, whose gaze violates the conventions of composition, looks out to sea and out of the edge of the frame, creating a sense of tension and mystery. These are the raw ingredients of a mininarrative, short story, or cliff-top drama.

It is a "found" scene and, of course, we have no way of knowing what the real story is, but that doesn't necessarily matter. These microstories are all around us, and when quietly observed, they can be a fascinating way to see and engage with the world. Some photographers prefer to create their own scenes using actors, models, and props to tell their stories. There's no right or wrong.

Think beyond the single image and use multiple images to reinforce the sense of narrative and give your story pace, rhythm, and cadence. The supporting images, above, with the path, and gorse bush conveniently shaped like a unicorn, add to the mysterious sense of place and narrative. Try rearranging images in difference sequences to see how the meaning alters. Making 4 x 6-inch prints and spreading them out on a tabletop can be a fun and useful exercise.

1 The conventional rules of composition suggest that the main protagonist should be looking into the frame, so he should be positioned on the left, with space for his gaze to travel. However, framing him to look out of the edge of the picture adds a sense of mystery.

2 The implied tension of the story is also accentuated by the two dogs, one of whom we cannot see. The two dog leashes provide an exciting and dynamic connection with their owner, especially with the one on the left looking away.

3 How we read this image will vary, depending on who is looking at it and what that person brings to the story. However, the raw ingredients for a mysterious mininarrative are here as a springboard for the imagination.

4 Adding additional images to support the story in a sequence is a good way to position the vibe and mood of the narrative. It is also a way to give a story pace and rhythm. Duane Michals (see page 102) is a maestro of storytelling and sequencing.

1

PROJECTS
A SENTIENT LAND

Thinking in terms of project-based work can be a key differentiator between hobby and serious photographers, and it will help you grow as a creative individual. Working over a period of time to develop a body of work is also a great way to immerse yourself in a subject. The more images you make and the more you investigate, inquire, explore, and experiment, the more you will evolve as a photographer.

The images on the facing page are part of an ongoing project called A Sentient Land. The project explores aspects of the landscape, using photography to describe the land as a living, dynamic, and visceral entity with a deep-rooted connection to myth and ancient folklore.

There are many ways to make a project cohesive, and a lot depends on how and where you imagine the final set of images being seen. For this project, cohesion was achieved by using a similar photographic approach throughout the set of images. On-camera flash, which is an unusual choice of tool for landscape work, was used to create a unified aesthetic and became a defining characteristic. It also spoke to the original intent, which was about looking at the landscape with fresh eyes.

Projects

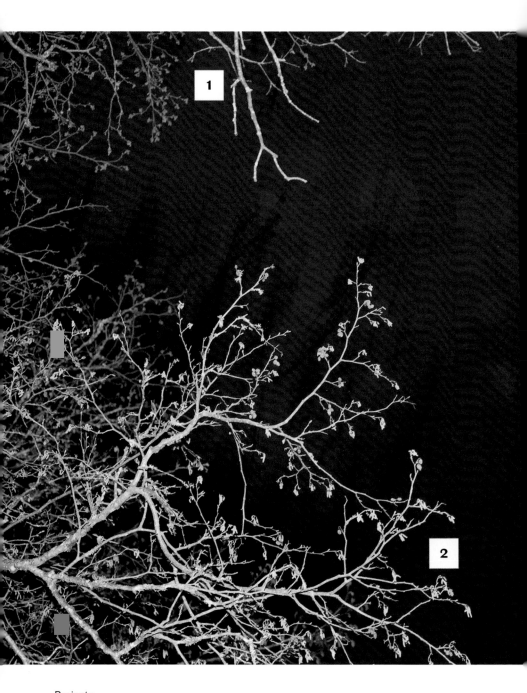

1 Using on-camera flash in the landscape is an unusual choice, but in this situation, the harsh, forensic, and otherworldly quality of the light emphasized aspects of the scene that might ordinarily be overlooked.

2 Using an on-camera flashgun restricted the choice of scenes to photograph, because there needed to be something in the foreground for the flash lighting to reach it. So, by default, the images in the set became layered, with the foreground being lit by flash and the background with natural light. This can create an interesting sense of depth, both visually and metaphorically. Sometimes, boundaries and restrictions such as this can help instead of hinder the creative process.

3 The set of images (page 141) needs to work as a unified whole, so certain considerations around lenses, cameras, and aspect ratios need to be made and committed to early on in a project. For example, in this set of images, a square-cropped, high-contrast black-and-white image would not work.

4 Most of this work was made during the period of the COVID-19 pandemic restrictions, when travel to far-flung corners of the world was not an option. This close investigation and subsequent appreciation of the topographies closer to home, in the less glamorous corners of rural Great Britain, was a delightful line of visual inquiry.

TRAVEL PHOTOGRAPHY
THE JOURNEY

What is travel photography? It's a weird question if you think about it. Search online for "travel photography" and you will see myriad colorful clichés of cormorant fishermen and characterful Cuban women smoking cigars and so on. Are these images really travel photographs, or are they some hackneyed, romanticized projection of what these places are like? It's something to think about when traveling with a camera.

The Royal Photographic Society in the UK describes travel photography as images that "communicate a sense of place," while Wikipedia categorizes it as a subgenre of photography concerned with documenting an area's landscape, people, history, customs, and culture. Both are vague and ambiguous.

If there is a need to classify, perhaps a travel photograph should be seen as something that describes the journey and not the destination. Maybe this image (see facing page) speaks to this notion. It's a picture of Mount Fuji, Japan, as seen through the window of a bus.

Typically, the magnificent and mysterious mountain is shown framed by cheerful cherry blossoms and other such photographic clichés. However, this image shows the mountain framed by a window and is not nearly so exotic, although it does capture something of the experience of my first encounter with the mountain.

While the fellow passengers were an annoying and frustrating frame to the fleeting vista, the sense of being in the bus and the notion of "journey" is communicated. The overhead lockers, air-conditioning vent, and fellow passengers all speak to the experience more eloquently than some lovely blossom.

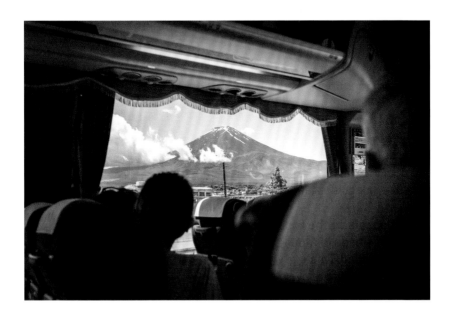

At first glance, this picture seems ordinary. However, look at it for a while and it becomes more nuanced. Perhaps the icing on the cake is how the tassels on the window curtains echo the shape of the distant mountain, giving the image extra resonance and depth.

What does travel photography mean to you? Think about it on your next journey, even if it's just your daily commute.

1 Using the coach window and fellow passengers as a framing device helps tell the viewer that this is a journey. While they were initially an annoying inconvenience, they ultimately reinforce the narrative. Because they are thrown into deep shadow, revealing little detail, they also provide a convenient compositional framing device.

2 Converting the image to black and white is a creative choice that superficially helps anchor the image in the documentary tradition, making it feel less like an accidental snapshot.

3 The tassels on the window curtain mimic the shape of Mount Fuji in the background. This is a wonderful accident, creating a lovely echo of shape and form between foreground and background. It's beautiful when the elements conspire in your favor like this.

4 My main camera was packed deep in my equipment bag and not easily accessible. However, I had a great little camera on hand and was able to quickly grab this shot. Smartphones can be excellent tools for situations like this— proof again that the best camera is the one you have with you.

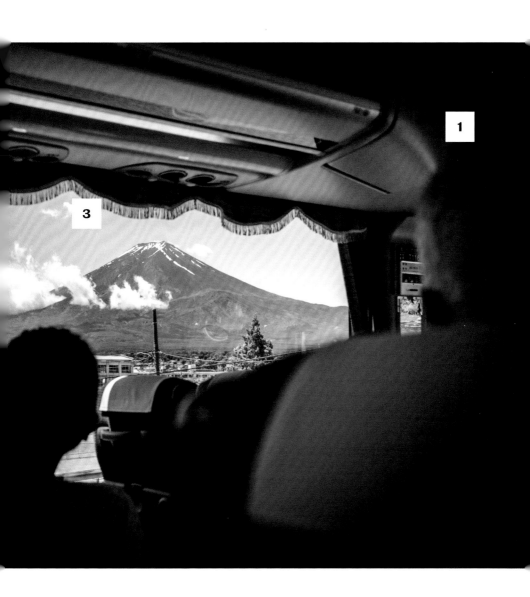

Travel photography

THE HUMAN FORM
HUMAN LANDSCAPES

The human form's beautiful shapes, curves, tones, and textures can create exciting and dynamic photos. Indeed, the nude has been a common subject throughout the history of art and photography. Incorporating aspects of the human body into the landscape to play off the topographical details and resonate with the land is an interesting way to approach both nudes and landscapes.

It's been done before—perhaps most famously by photographer Bill Brandt, whose stunning nudes on the beach do just that. But just because it's been done before doesn't mean there's no need to do it again. Initial forays into this or similar themes may feel derivative, especially if they've been explored so eloquently in the past. But don't be put off—get started and soon enough, your own style, vision, and voice will start to emerge.

Finnish-American photographer Arno Rafael Minkkinen also artfully incorporates the human figure into the landscape, and some of his images take on a playful Brandt-esque vibe. However, unlike Brandt, Minkkinen uses himself as the subject. Quite how he achieves this in some of his photographs is a mystery, but they are sublime nonetheless.

The human form

1 This image evolves the concept of the selfie. The legs belonging to two different people suggest an intimate relationship and a connection with the place. It is perhaps more poignant and visceral than two grinning heads photographed from arm's length with a front-facing smartphone camera.

2 Looking at the shapes, tones, and textures of the legs and dislocating oneself from the fact that they are human legs, it's possible to see the forms as topographic features of the beach. Exploring the human body in this way can be visually interesting.

3 Making the photograph black and white is a personal choice. However, removing the color helps direct the viewer's attention to the shapes, tones, and textures. Consequently, the legs arguably appear more integrated into the landscape.

4 The use of negative space in the composition, with more than half the image area being nothing more than bland sky, was a deliberate decision to emphasize the sense of intimate togetherness in the vastness of the universe.

1

2

The human form

LANDSCAPES
BEYOND THE CHOCOLATE BOX

Capturing a chocolate-box landscape can be undeniably rewarding. However, if you want to create pictures with a deeper resonance that speak to your sense of place, you may have to dig deeper and see differently. The wise words of American photographer Robert Adams may be a helpful reference. Adams was one of a pioneering group of photographers in the 1970s called the New Topographics (see page 78). He speaks eloquently on landscape photography, and in his book, *Beauty in Photography*, he suggests three "verities" of a successful landscape photo: geography, autobiography, and metaphor.

By geography, he is referring to the record of place and what makes it unique—for example, topography, light, and weather. By autobiography, he is suggesting that the photographer's sense of place comes into play and informs the image through personal expression. And by metaphor, Adams asks if an alternative meaning can be read. He suggests that each verity, taken in isolation, has the potential to be boring, trivial, or dubious, but that together they can reinforce each other and produce an image with depth and substance.

Projects

The image above reveals passengers admiring a glacier from the deck of a cruise liner. Most people were trying to capture an image a little like the one on the facing page. However, by taking a literal and existential step back to include the passengers and the deck into the scene, you can create an altogether different type of image. At first glance, it might be less glamorous than the image without them, but it is a more nuanced and interesting image that speaks more eloquently to humanity's relationship with nature and the environment. The image of the glacier alone only really speaks to Adams's sense of geography, and while less immediately glamorous, the image with the passengers touches on all three verities.

1 As autobiography, the act of taking a step back and including the passengers observing the glacier from the ship alters how the image is read and speaks to the sense of place I was feeling (see page 130); by taking a literal and existential step back, I was revealing the bizarreness of humans observing a melting glacier from the deck of a ship.

2 As metaphor, the image could be seen as a reflection of our relationship with the environment. Notice how the top third of the scene shows a glacier, the middle third a swath of humans, and the bottom third the wet surface of the ship's deck. Perhaps the glacier could be read as melting through the wall of humans.

3 As geography, we can describe the image literally, as the photograph reveals passengers on a ship, observing a glacier. The weather is damp and misty.

4 The composition has a formal quality, with careful attention paid to keeping the horizon level. The shape of the group of passengers, along with their reflections on the wet deck, creates subtle triangular leading lines that lead the viewer's eye into the frame. Perhaps the few passengers that are looking up and out of the frame, and away from the glacier, add a sense of mystery.

Projects

3

4

STREET PORTRAITS
NIGHT LIFE

Photographing strangers in the street can be an intimidating prospect, even for a seasoned photographer. However, build up the courage and more often than not you will be rewarded. There are many ways to approach the subject. Some photographers like to use long lenses, keep their distance, and take shots on the sly. This can be effective, although it feels sneaky and might have some ethical considerations to think about.

These portraits were made as part of a project documenting nightlife in Miami Beach, Florida. The ambition was to get up close and personal and reveal the characters in all their unflinching glory. There was nothing sly or sneaky about the approach to these portraits. To make photographs this close required a certain amount of interaction and close proximity to the subject. While some people were not interested in taking part, most were, and over a couple of nights of shooting, there were enough images to form a small body of work.

It's worth noting that photographing people in a public space, especially if you are working in a candid style without seeking permission from the subject, can be a violation of the law in some countries, so be sure to check that it is legal where you're planning to shoot. Regardless of the law, be considerate and respectful of your subject.

These portraits
were made into large
prints as part of an
exhibition in Miami
Beach, Florida. Their
size (much larger
than life size), along
with their forensic
quality, made a real
presence.

Street portraits

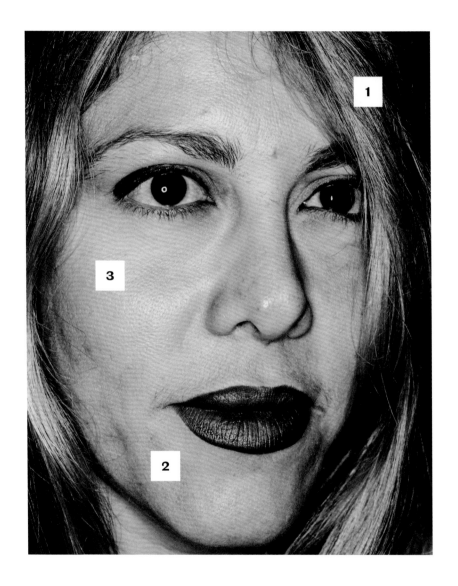

Projects

1 Approaching someone to take their portrait can feel awkward. However, the worst that can happen is that they say "no." Often, people are willing to oblige, especially if you explain what your project is about and why you want to photograph them. Use a business card to give them your details and offer to send them a copy of the image.

2 Many people will instinctively expect to smile for a portrait. However, a big grin can make a portrait feel more like a snapshot. There's nothing wrong with that but try to take some without smiles, too—in general, they make more engaging and meaningful pictures.

3 These portraits are part of a small body of work and need to work together as a whole, with a sense of continuity from one image to the next. So, a consistent style of lighting and framing was used in all the portraits. Making these decisions before shooting helped solidify the idea.

4 You don't want to waste your subject's time, so before asking to take his or her portrait, make sure all your settings are worked out and you know where you'd like the person to be positioned and so on. There's nothing worse than fiddling with camera settings while your subject is waiting, which will lead to boredom and irritation.

Street portraits

CREATIVITY
TOKYO DREAMS

An explosion of grit, grain, color, and noise describes this vision of central Tokyo. The image seen here is an extreme enlargement, created by zooming into the circular image below. It's one of many made by zooming in on the buildings, windows, balconies, fire escapes, air-conditioning vents, and so on, suggesting an exploration of the metropolis, with an intriguing, almost voyeuristic sense of narrative.

The source image was hand-colored (using a digital pen and iPad) and proved an interesting way to spend a lot of time with a photograph. The longer I spent coloring, the better I got to know the city and explore it in an exciting way. It also stimulated my imagination, and I was soon creating stories in my mind from the little vignettes on my screen.

The snapshots, which are essentially just screenshots of the larger circular cityscape (see left), create little abstract vignettes of Tokyo life and can be seen as single images in their own right. This image is one of about 30 extreme crops, each zooming into minute detail. Instead of trying to hide and get rid of artifacts and grain that resulted from the extreme crop, I decided to embrace the rough-and-ready vibe. In fact, to amplify the effect, I added even more grain to accentuate the effect and make the images feel even more contrasty, edgy, and garishly colorful.

Creativity

1 The gritty, grainy vibe was the result of making extreme enlargements of a small area of the larger cityscape. Instead of fighting it, the effect was embraced wholeheartedly and more grain (digital noise) was added to accentuate the vibe.

2 Using painted color is a lot of fun. However, it's just as satisfying, maybe even more so, to make a black-and-white print and use real paint or inks to create the effect. In this case, painting a photocopy-quality printout would be even better.

3 Spending a lot of time with one image can be an interesting way to explore its contents. Out of this source image, about 30 extreme enlargements were made. These were eventually made into a 24-page zine.

4 This project evolved out of boredom during the COVID pandemic restrictions. At times, being bored can be a great way to stimulate creativity. With so many distractions in modern life, especially from smartphones, these moments are rare, so seize them with gusto. Just make sure you've got a camera with you!

STORYTELLING
MODERN NATURE

Telling stories about wildlife, the environment, and humanity's relationship with nature is a subject that touches everyone, everywhere. It is a subject of vital importance and relevance. As a language, photography can be a great form for commenting on this relationship, and there are many ways we can tell stories or construct narratives around it.

Typically, wildlife depictions of the Alaskan region might show a bear snatching salmon from a waterfall, an eagle swooping on its prey, or a moose silhouetted against a stunning sunset. These are all admirable depictions. However, there are other ways to communicate and articulate ideas around humans and nature, which can be just as effective, if not more so.

For this image, which is part of a bigger series called The Lost Frontier (see page 176), the Alaskan wolf rug is being used to graphically reveal the crass way we, as humans, have commodified this beautiful wild animal by killing it, skinning it, turning it into a rug, and hanging it on the wall with a price tag.

Stylistically, the image is hard hitting—it doesn't hold an aesthetic allure that would attract many people to hang it on their wall. However, as a way to communicate an idea, grab people's attention, and make a point, it has an effect that is maybe more powerful than a cute wildlife photograph. Using harsh on-camera flash and a bold, confident composition adds to the impact.

Storytelling

1 Including the price tag was a strategic way to emphasize the crass commodification of this beautiful animal. That it is positioned just above the head further fuels the impact of the shot. Needless to say, the teeth and glaring eyes from the central point of focus pack a punch.

2 This rug, which was one of many, was attached to the wall, so the point of view is looking up from below. This angle helps create a strong, dynamic composition that has energy, grit, and impact. The line of the outstretched front leg also helps draw the viewer's eye to the focal point.

3 On-camera flash helped with the relatively low light, but perhaps more important, its unforgiving harshness accentuated the brutality. This is no place for soft, atmospheric lighting, and the hard-hitting flash with crude shadows adds to the grit.

4 The color grading has a slight yellow tint, which is simply part of the overall aesthetic of the larger project and is in keeping with other images from the same series. This helps the body of work feel consistent.

TIMING
THE DECISIVE MOMENT

The essential ingredients of a photograph are light and timing. The great French photographer Henri Cartier-Bresson is perhaps best known as the godfather of street photography, which for many is all about capturing the moment.

In 1952, Cartier-Bresson published a book called *The Decisive Moment*, which is arguably one of the most famous books in the history of photography. Since then, capturing the "decisive moment"—that split-second moment in time when everything conspires to come together into a harmonious composition—is considered by many to be the ultimate goal. Often, it is a moment so fleeting that it would be missed in the blink of an eye.

"The essential ingredients of a photograph are light and timing."

Many street photographers will hunt and prey on the streets, waiting, lurking, and seeking that elusive shot.

This image is perhaps not such a fleeting moment in time, but there are similarities with the decisive moment in its making. Waiting for the subject to move into the exact position was vital for the image's success. Along with the critical timing, there's also an element of implied narrative, with the shrubs in pursuit of the mobility scooter adding a playful element.

Here, you can see the
sequence of images in the
moments before and after
the main image (in red)
was taken.

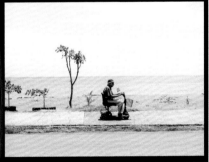

Timing

1 Violating the rules of composition, the horizon has been positioned exactly in the middle of the frame. Likewise, the subject is central. In this case, it works and helps to reinforce a sense of isolation.

2 This image is all about timing and waiting for the main subject to be exactly where it is. Seeing a scene like this unfold, anticipating the action, and getting into position is a good skill to practice and hone.

3 While this image is mainly about the critical timing, there is also a sense of implied narrative, with the shrubs in pursuit of the mobility scooter. This sense of storytelling adds nuance and could be read in many ways.

4 Converting the image to black and white was an artistic choice, which was made so that attention was focused on the core elements of the scene: the mobility scooter, the shrubs, sidewalk, and ocean. The color was drab and not adding to the story.

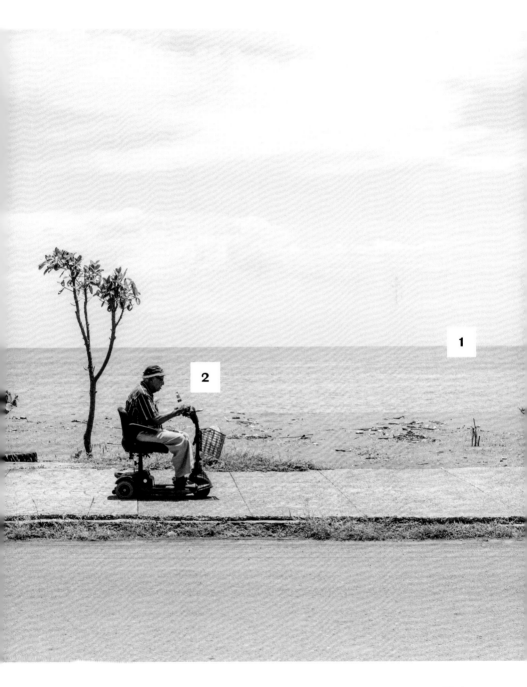

Timing

THE ART OF
LOOKING SIDEWAYS
IT'S A SMALL WORLD

This is a macro image of a giant grasshopper, taken in the controlled environment of a tabletop studio and shot with a macro lens (see page 29). Many smartphone cameras will let you focus superclose, too, so you don't necessarily need any special equipment.

The tones of the image were inverted using an app to make it appear negative. In other words, everything that was dark became light and vice versa. This was a purely artistic affectation and an attempt to emulate the delicate lines and luminance of a graphite pencil drawing.

As chance would have it, when the image was accidentally flipped on its axis so that it appeared vertical, it took on an alien-like vibe, with arms, bulbous eyes, and succulent lips. This was interesting and worth further exploration. Duplicating the image and flipping *"Photography can* the second image on its axis so that the two *be fun and weird."* "alien" grasshoppers were facing each other created an unusual macro study that feels like two alien lovers floating in space.

Photography can be fun and weird, and the act of taking one thing and reimagining it as another by turning it on its side or upside down is an interesting discipline to experiment with. It can help nurture your seeing, so you are focusing on form and shape—and maybe a new form of content can be realized.

The art of looking sideways

1 Exploring the world in close-up will offer myriad opportunities for the creative photographer. You don't necessarily need to be using an expensive DSLR camera with a macro lens, because most modern smartphone cameras will have good macro capability.

2 Inverting the image so that the tones are reversed like a negative gives the image an unusual luminance, which emulates the delicate tones and lines of a graphite pencil drawing. This alone gives the image a transcendental vibe.

3 Rotating the giant grasshopper by 90 degrees, so that it's effectively standing up, alters the perception of the insect. As a viewer, it's interesting to note how you see the shapes differently—suddenly, you can see alien-like arms, lips, and eyes.

4 Introducing a copy of the original image and flipping it so that there's a mirrorlike effect adds another twist. The composition is harmoniously balanced, but more interestingly, it looks like two alien lovers are floating in space.

SAY SOMETHING
THE LOST FRONTIER

Project-based work can be a stimulating way to immerse yourself into making photographs and explore a story, place, or theme. People new to photography tend to think in terms of single images, and there is nothing wrong with doing so. However, if you have an inquiring mind, there may be a time when you want to explore a subject in-depth over an extended period.

If you are working on a project, having something to say can be as important as the making of an image. These images are the basis of an ongoing project that evolved while on multiple trips to Alaska during the peak tourist season, just before COVID-19 hit the world. It's titled The Lost Frontier and is broadly concerned with exploring the complex relationship between humans and their environment. The images aim to raise questions about the world we live in and our connection to it.

Tourists are drawn to this region en masse, mainly via cruise ships, to see the wild vistas and marvel at glaciers and other natural wonders. The Lost Frontier is concerned with the dichotomy between mass tourism, consumer culture, and the environment. Imagery from and of the region is typically dominated by epic, romanticized chocolate-box vistas and cute wildlife shots. However, the reality is starkly different, and this informs the project.

Having an idea to guide you helps develop a body of work, and over time it may evolve and mutate as you learn more and become immersed in the subject. This can be a rewarding way to work. Making stylistic choices about how you photograph is important, too—each image will end up being a part of the bigger picture, so consistency of vision, rhythm, and pace all need to be considered.

Say something

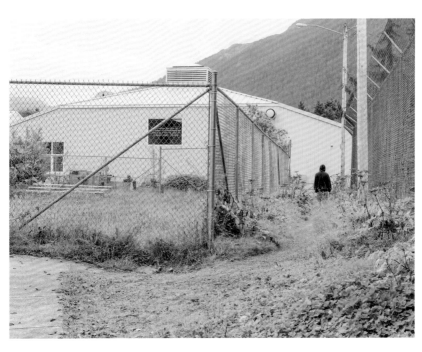

1 Thinking of a title is a useful way to anchor a body of work and help inform the viewer of your intent. The Lost Frontier is a slightly obvious play on the phrase "the last frontier," which is what the region has been historically called, because it represented one of the last untamed regions of wilderness. Changing the word "last" to "lost" plays on the idea that elements of this wild area have been lost to modern life, which to an extent, they have.

2 Captions and a short, written statement can be useful. It may feel like a drag having to write stuff, but besides providing helpful background information to the viewer, it can also help you articulate your own thoughts.

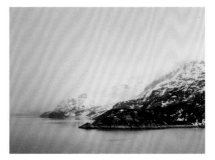

3 Being consistent in your vision and technique helps unify a body of work, but that's not to say everything should be the same. Differences in viewpoint, distance, framing, and content will help give a body of work pace and rhythm. However, imagine there was a studio-lit, high-contrast, gritty black-and-white portrait mixed in with these images—it would feel incongruous.

4 How you edit, sequence, and present your work plays an important role. The eight images here are a small representation of a larger piece of work, and over time more trips are planned to expand on the work. You may need to make several different edits, and editing for an online gallery or Instagram post may differ significantly from a magazine feature or even deciding which eight to put in this book.

CREATIVE STRATEGIES
REPETITION IS CHANGE

Written on one of the Oblique Strategies cards created by Brian Eno and Peter Schmidt are the words "Repetition is a form of change." The cards were conceived to help anyone stuck in a creative rut, the idea being that the typically vague instruction stimulates a new line of creative inquiry. They're great cards!

This particular card plays well into the idea behind this set of images. Presented here are 12 photos of the ocean. They have all been made from more or less the same vantage point and the horizon is exactly in the middle of each frame and perfectly horizontal. There is no foreground interest, no leading lines, nothing to anchor anything to a rule of thirds or the golden mean. In fact, there's nothing in them—they're arguably boring images.

However, the constantly changing tones and shifting hues and textures picked up by the shimmering light licking the water's surfaces have an enduring fascination. By photographing the view in exactly the same way, these differences are emphasized. While the images might work individually, they also take on a different dynamic when seen together.

Naturally, the idea here is not to fixate on oceans but on the idea of repetition, so think of something you can easily get going on. Try anything, from mailboxes and teacups to pebbles and tree stumps. It is worth mentioning that photographing the ocean in this way is clearly a "thing." Check the work of Hiroshi Sugimoto, Shōmei Tōmatsu, Thomas Joshua Cooper, Robert Adams, Jem Southam, Nicholas Hughes, and Garry Fabian Miller for more insight and inspiration.

Creative strategies

1 All the images in this set were taken from more or less the same vantage point: the eighth deck of a cruise ship. The same focal length of the lens was used to keep the vista consistent.

2 The horizon has been positioned in exactly the same place: the exact center of the frame. This choice made it easy to replicate the look and feel of the composition from one image to the next. Consistency is key. Keeping the horizon level is more difficult than you may think, but there are in-camera tools to help you do so.

3 Picking a theme, such as the ocean, which can often change dramatically within a matter of minutes, works well. However, you don't have to be at sea, because there are opportunities everywhere. Just look up, for example, at the sky.

4 Placing the images into a grid is a great way to emphasize the differences. However, there are other ways. For example, make a zine with a different image on each page, or create a video sequence. This set of pictures was made into a 35-second movie using a smartphone app.

2

4

PORTRAITS
UMBRELLA MAN

Making portraits of people is a great way to connect with the world and explore the delightful similarities and differences between us. This shot of a security officer called José, taken in Costa Rica, was one such encounter. It was an ordinary scene, the kind of situation that's easy to walk past without giving it a second glance. However, in this case, the striking shadow of the umbrella and the stark whiteness of the background caught my attention, albeit fleetingly in my peripheral vision. A brief exchange in pidgin Spanish and José seemed happy to oblige, graciously allowing me to take several images. I gave him a card so he could contact me directly if he wanted a copy of the image, which he did. It was a great exchange.

The harsh overhead light was intense. The lightness of the background and the crisply defined shadow of the umbrella, and even the fact that the subject was using an umbrella, all speak to the story and help communicate the intensity.

The art of looking and noticing is a theme that runs through this book, and for good reason. Being open-eyed and receptive to the idea that there are potential images to be made just about anywhere is a useful state of mind to adopt. In fact, it is often the more humdrum locations or situations that can yield the best results.

Portraits

1 A sense of isolation is emphasized by the starkness of the environment. The white background, which is the side of a ship, and the concrete foreground are featureless. It is the perfect background for the scene. Positioning the subject more or less dead center with a large amount of space around him also enhances this vibe.

2 Seize the moment and always be alert to the idea of a potential photo. There was nothing obviously photographic in this situation and I just saw the shot in my peripheral vision. Thankfully, the security officer, José, was obliging and let me take several shots.

3 Create a business card with your contact details on it. It's always good to make a connection, build rapport, and offer to send a copy of the photo to the subject, if they want you to. In this case, José from Costa Rica was thrilled to receive a copy of the photo.

4 The umbrella and its shadow resonate with one another beautifully, which is what makes the image work. For a shadow to fall like this, the sun must be directly above the subject, which when combined with the stark white background, emphasizes the intensity of heat and light. The brightness can fool your camera's light meter, and it may try to make everything a muddy gray. Overexposing by a few stops will fix this.

INDEX